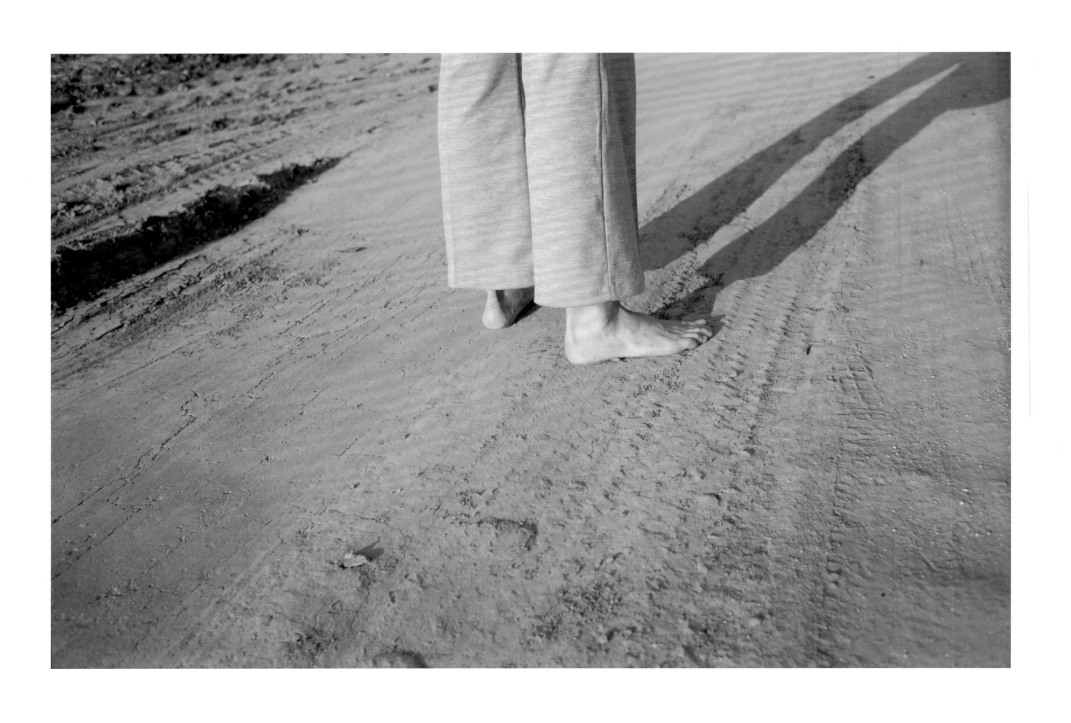

William Eggleston
FOR NOW

AFTERWORD BY MICHAEL ALMEREYDA. ADDITIONAL TEXTS BY LLOYD
FONVIELLE, GREIL MARCUS, KRISTINE MCKENNA AND AMY TAUBIN

TWIN PALMS PUBLISHERS 2021

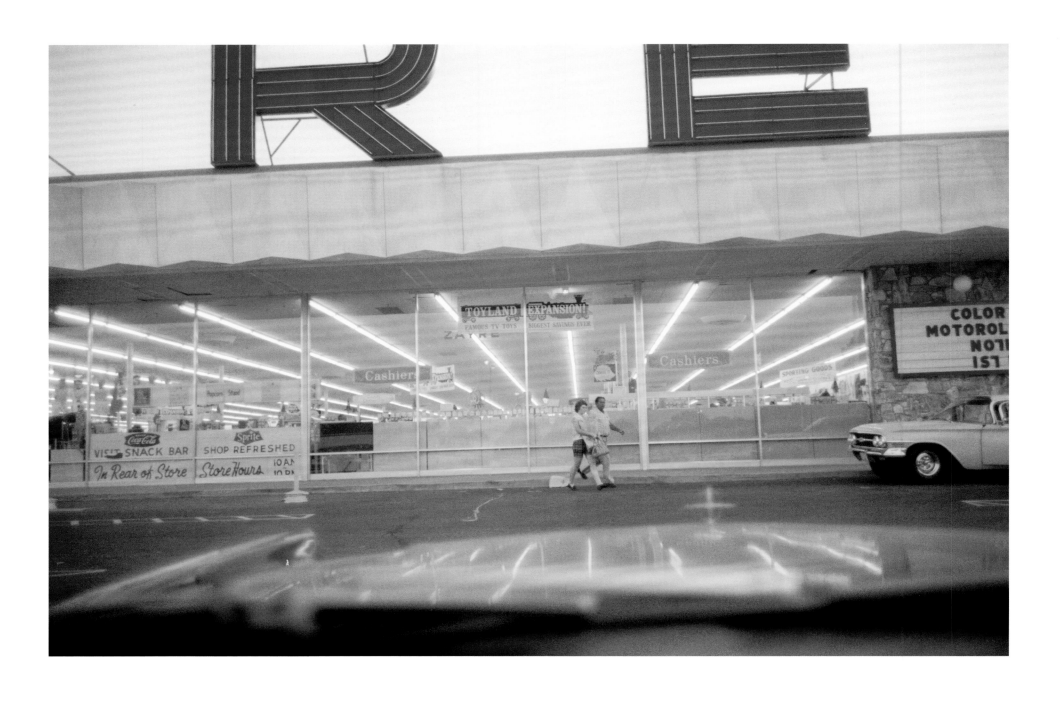

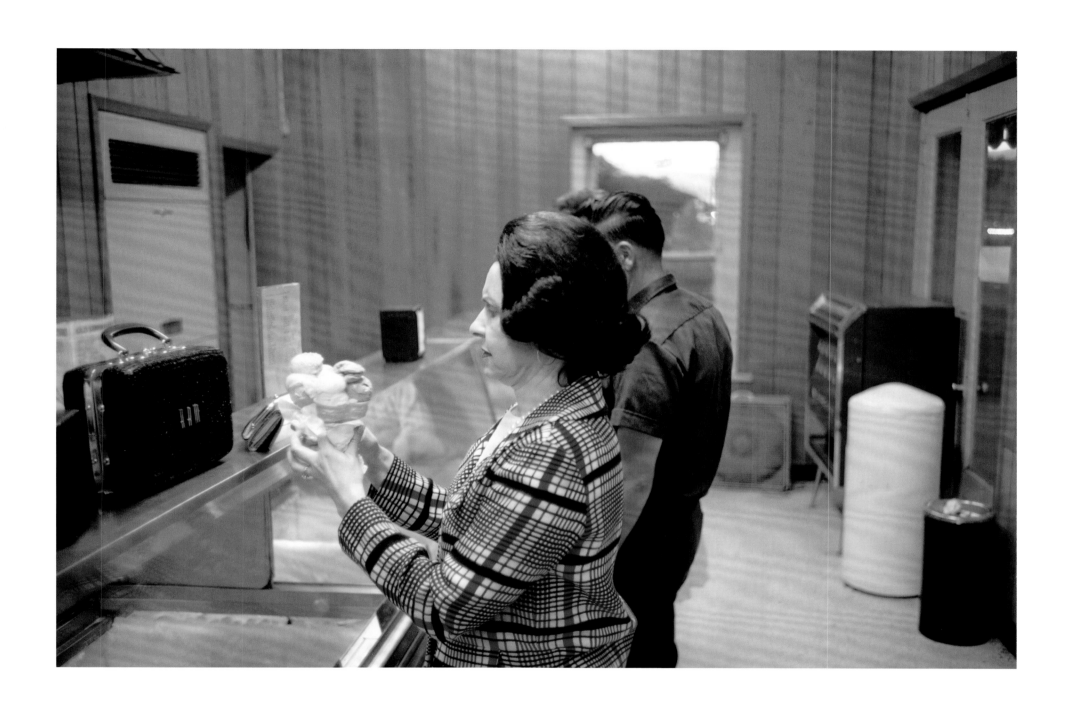

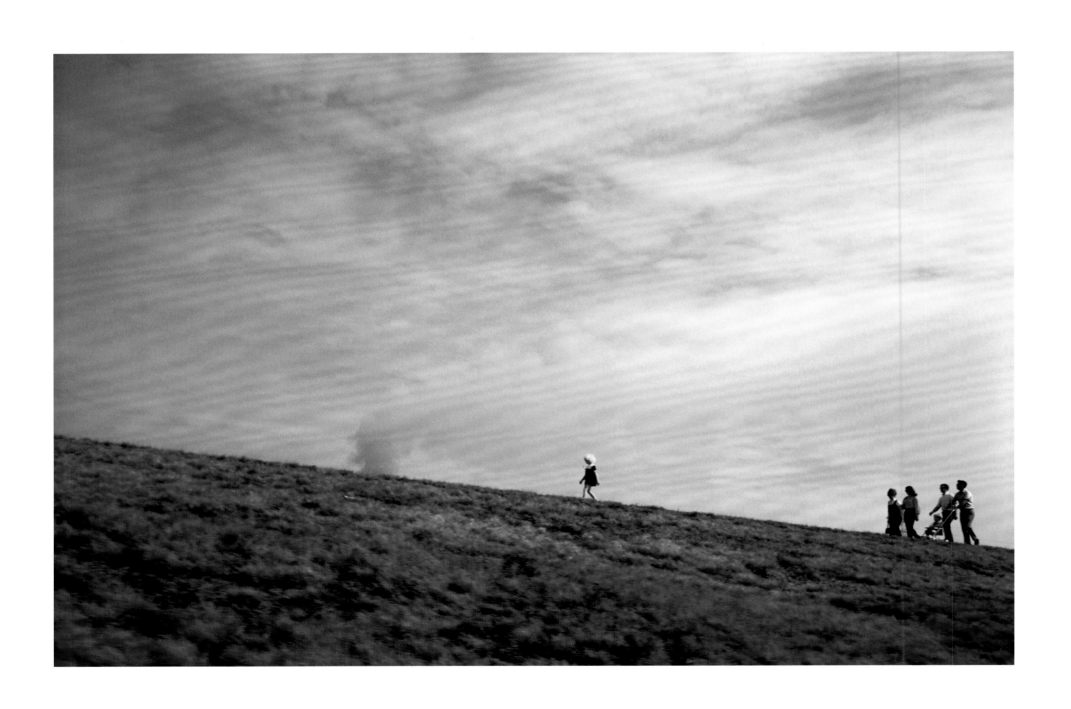

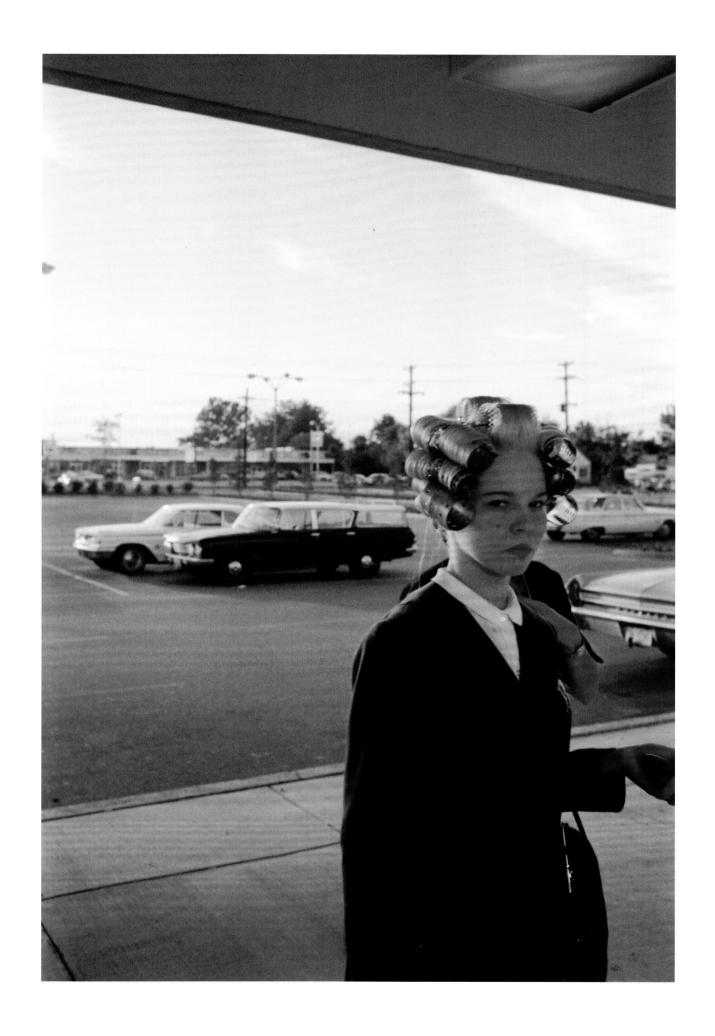

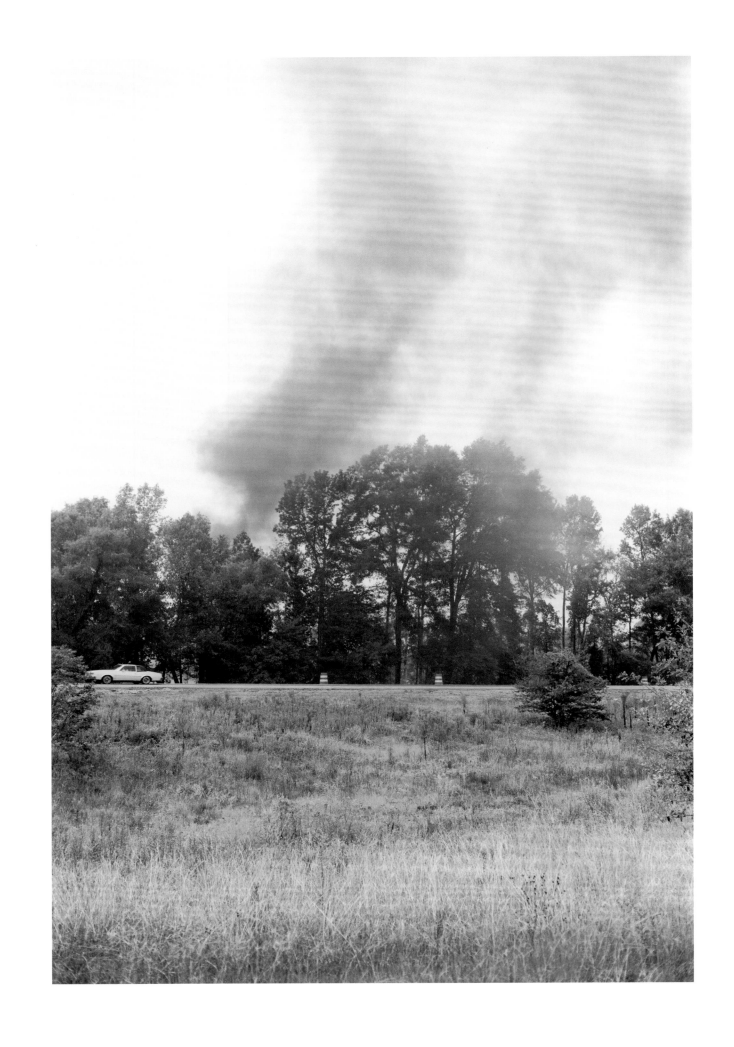

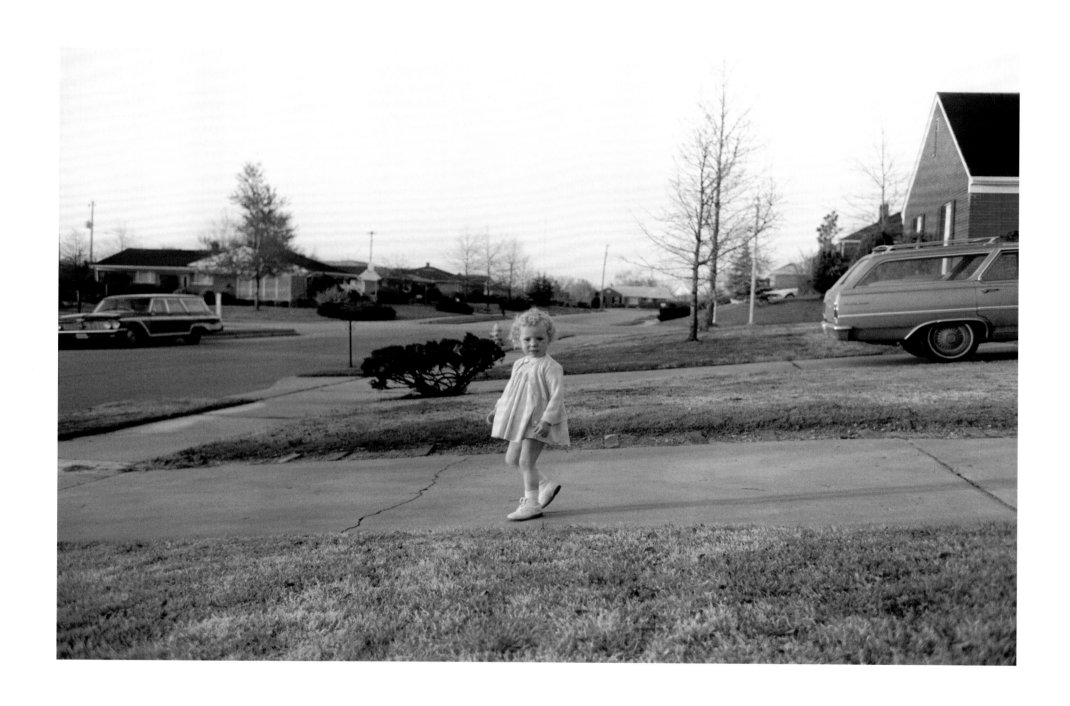

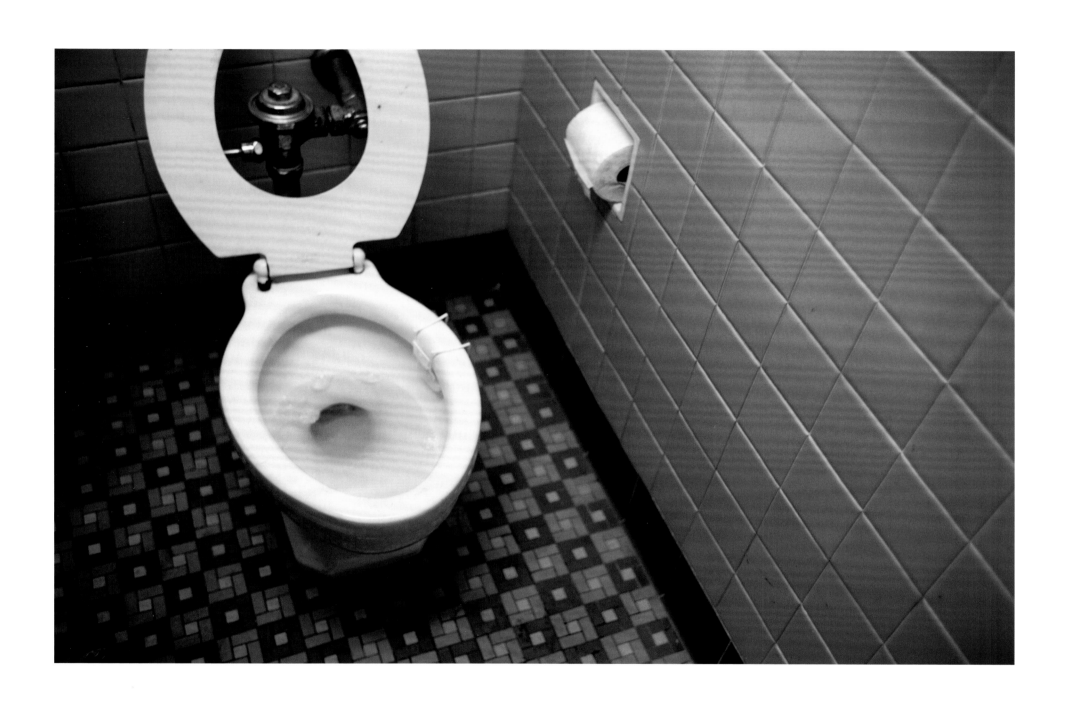

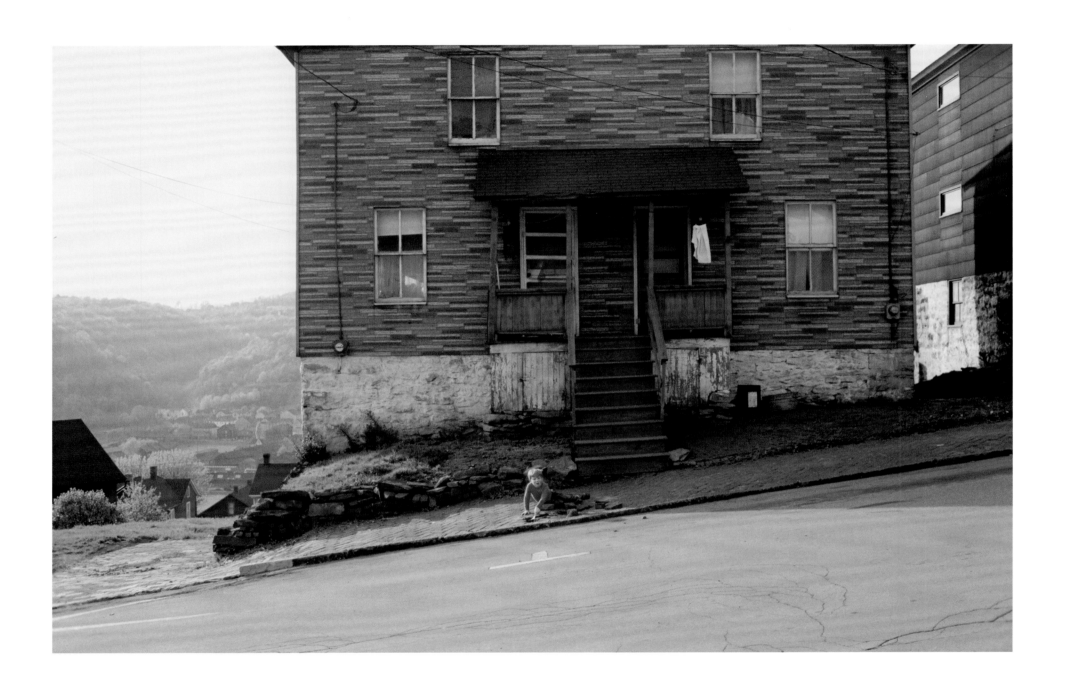

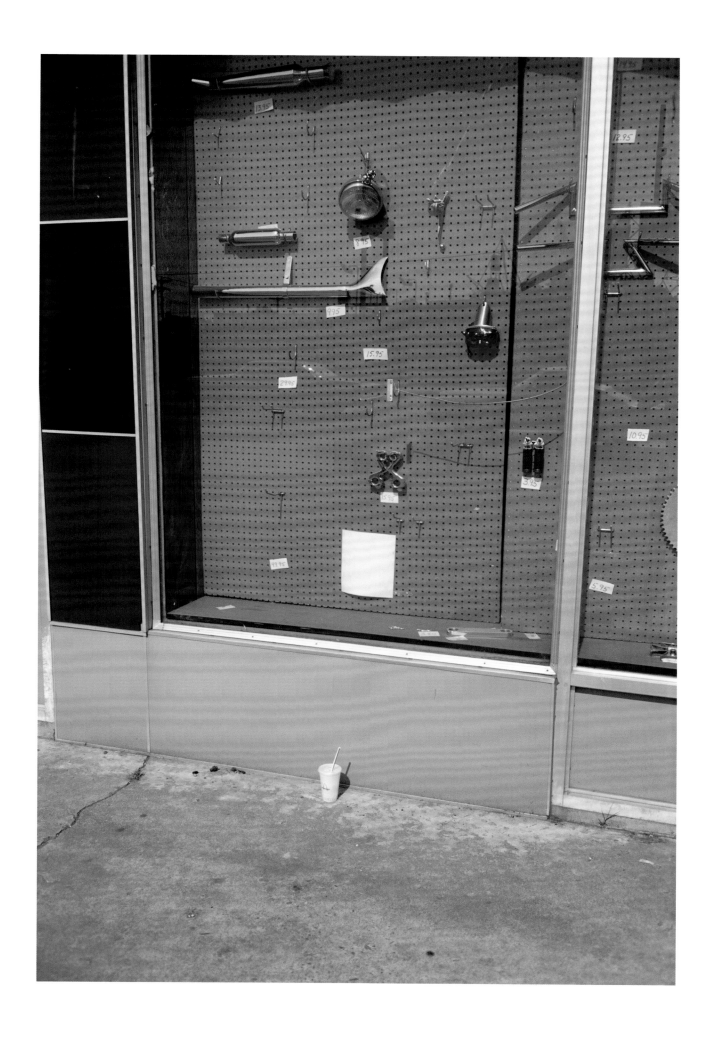

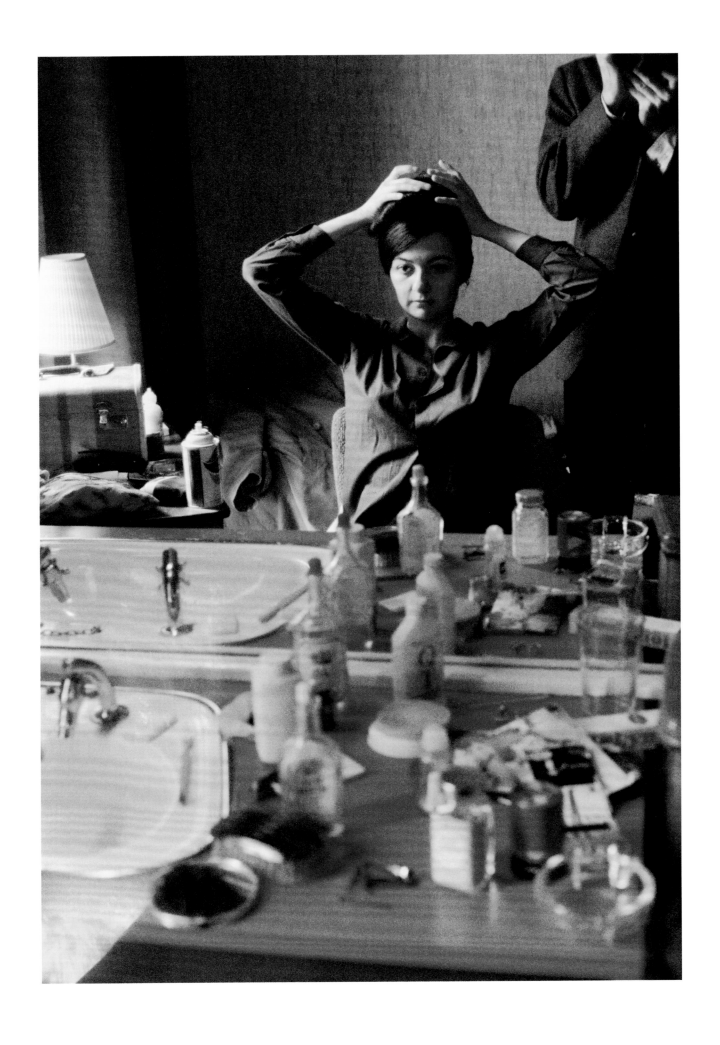

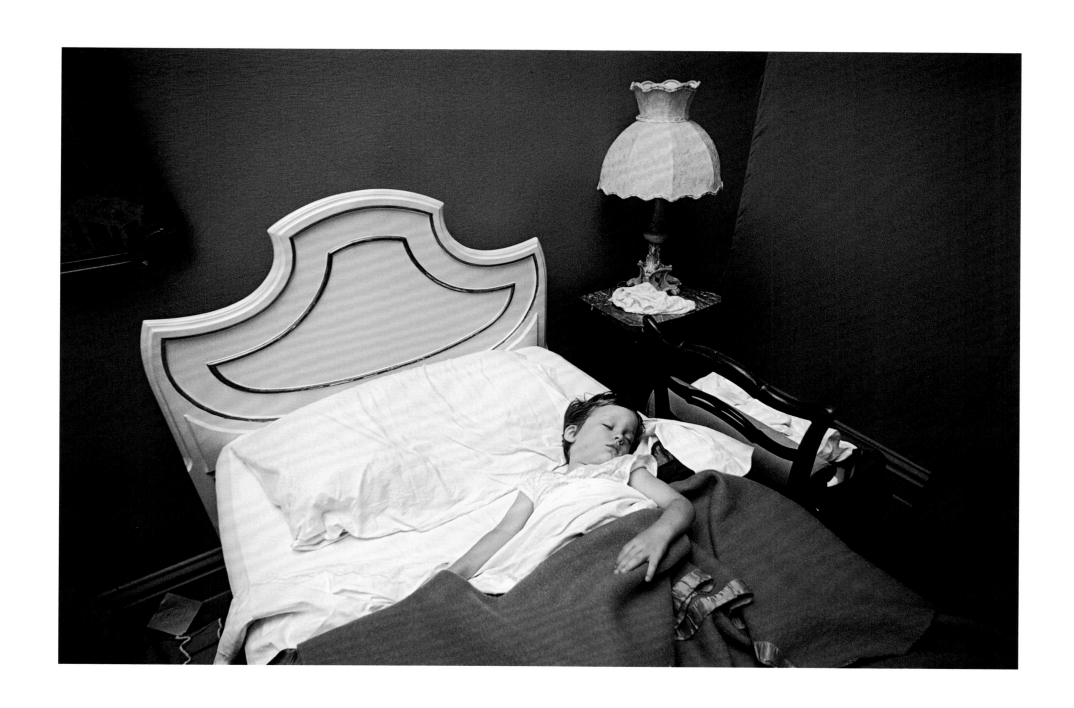

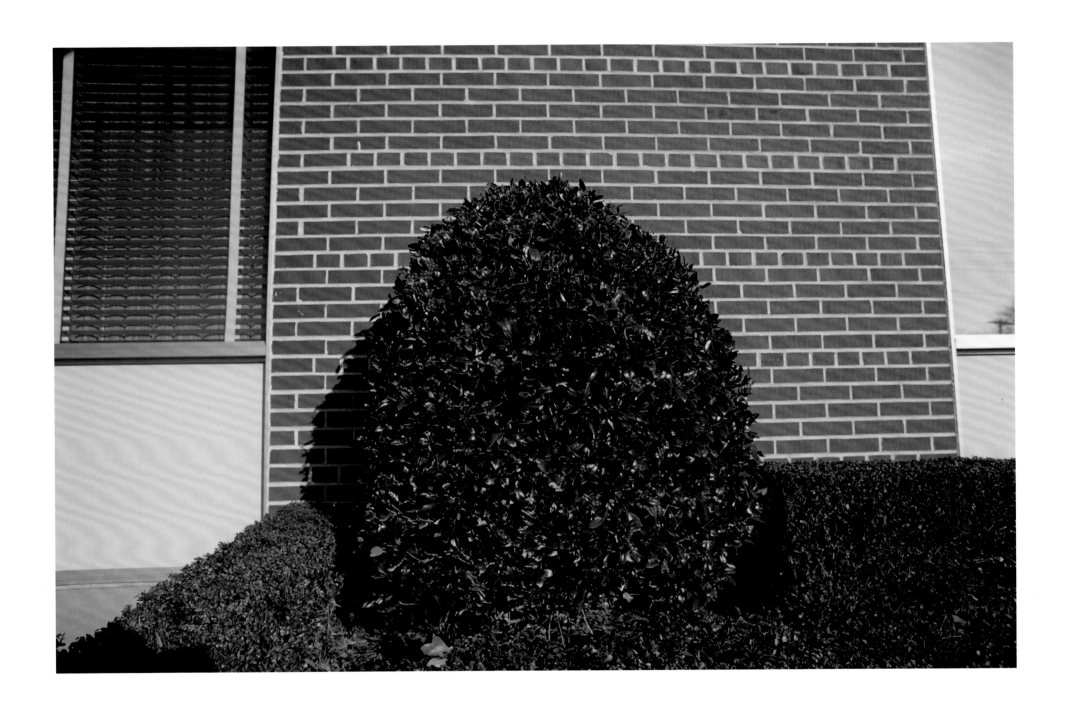

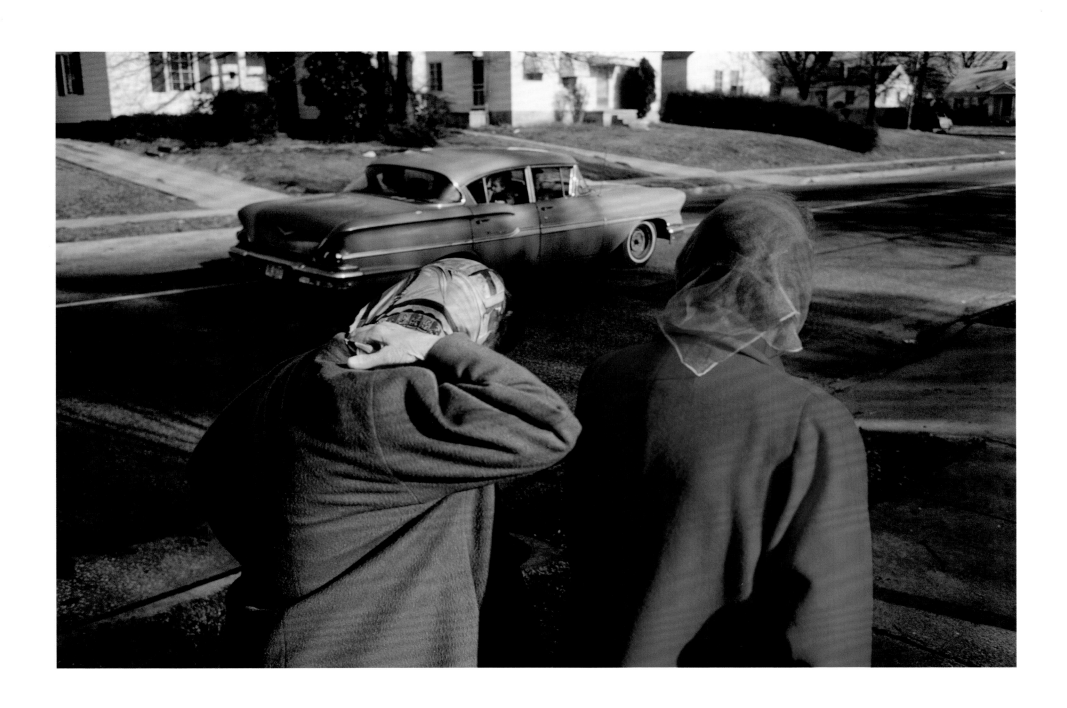

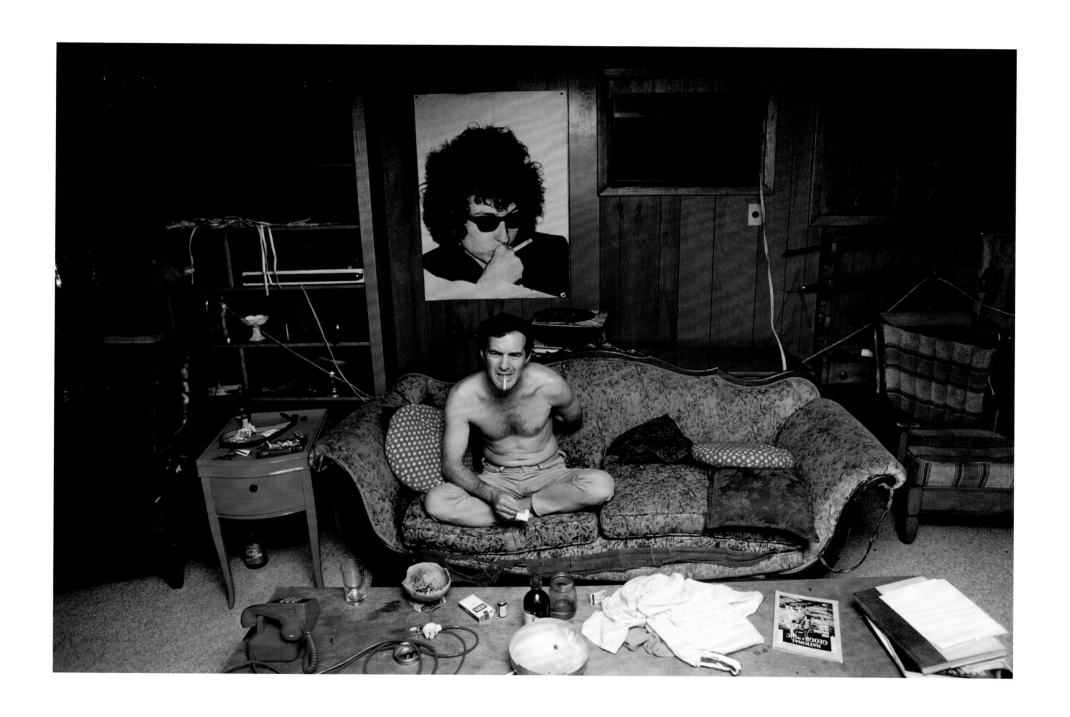

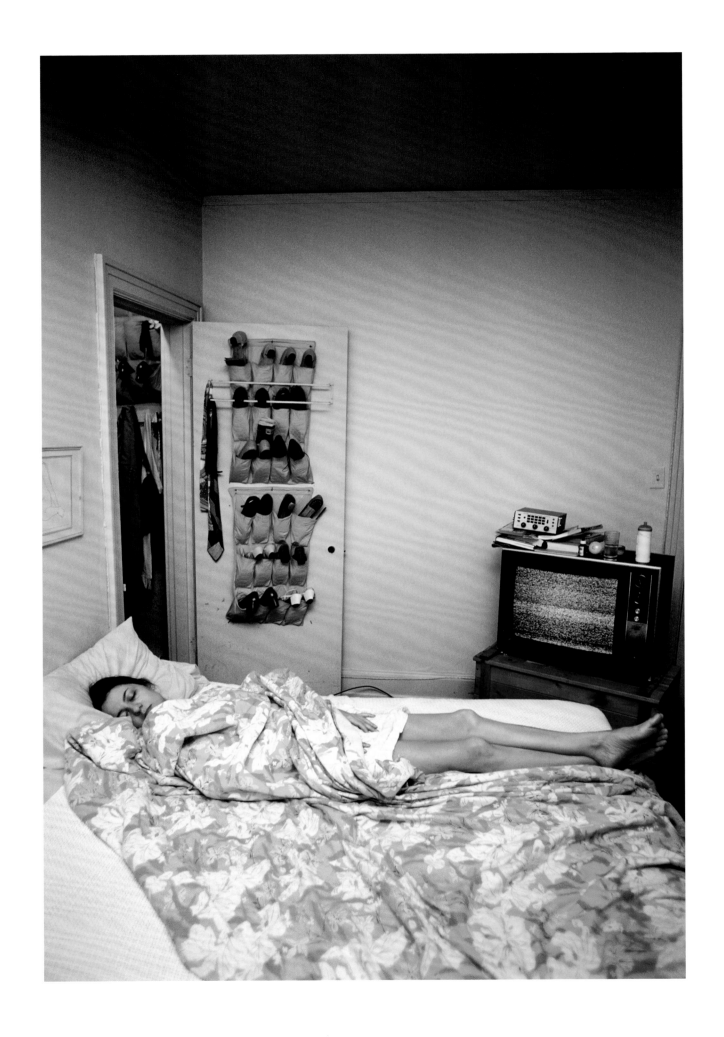

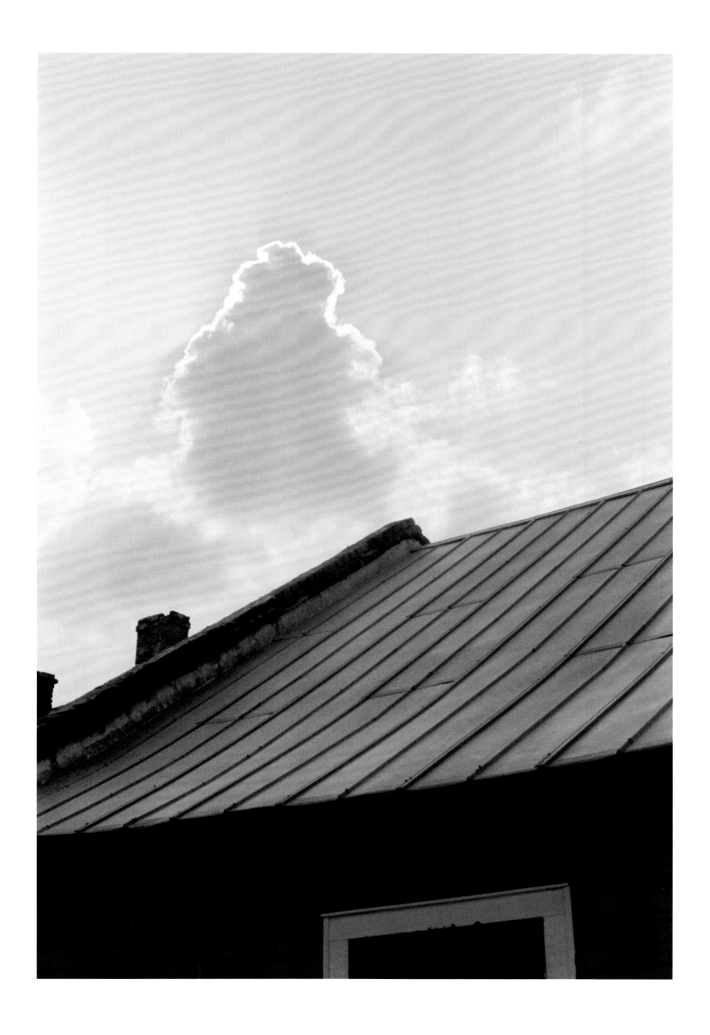

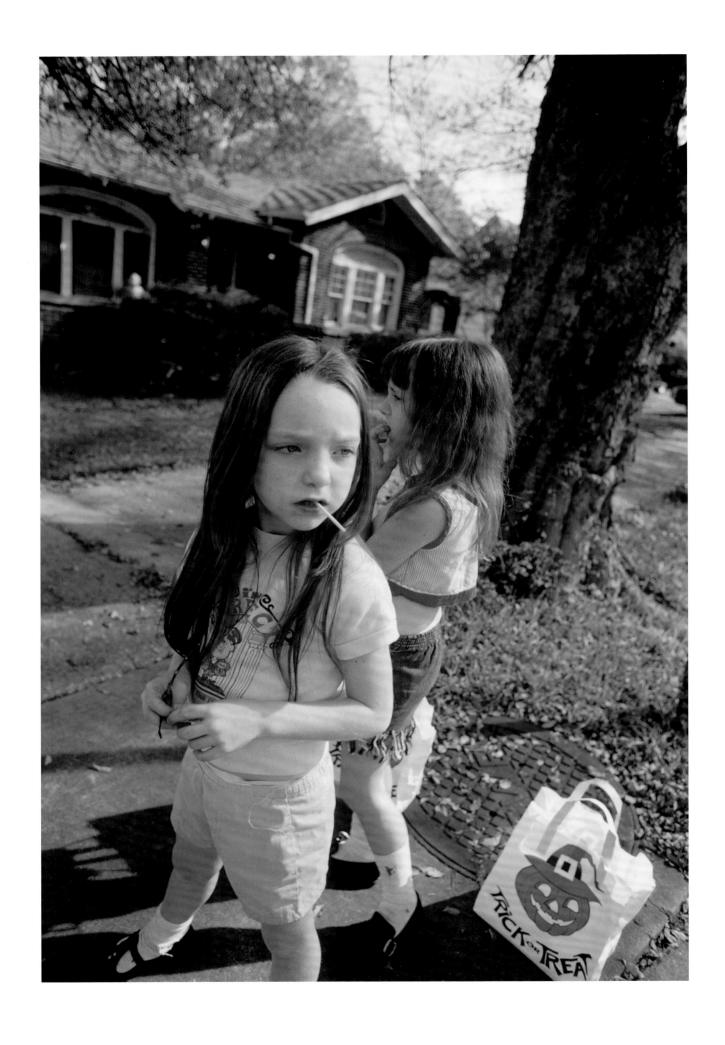

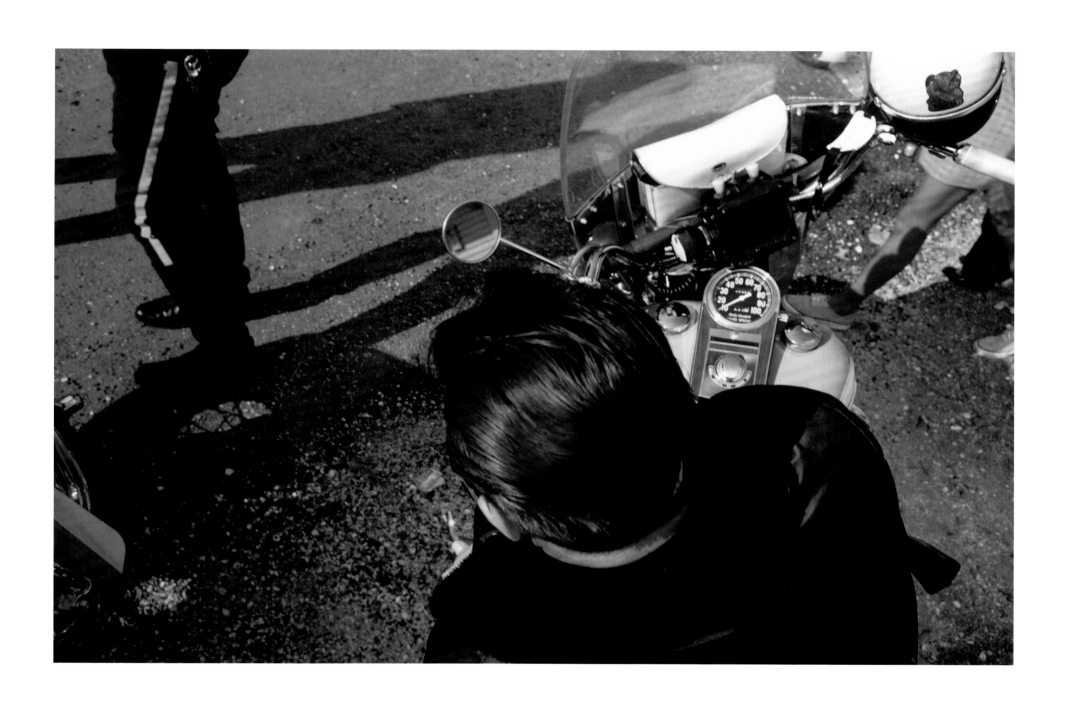

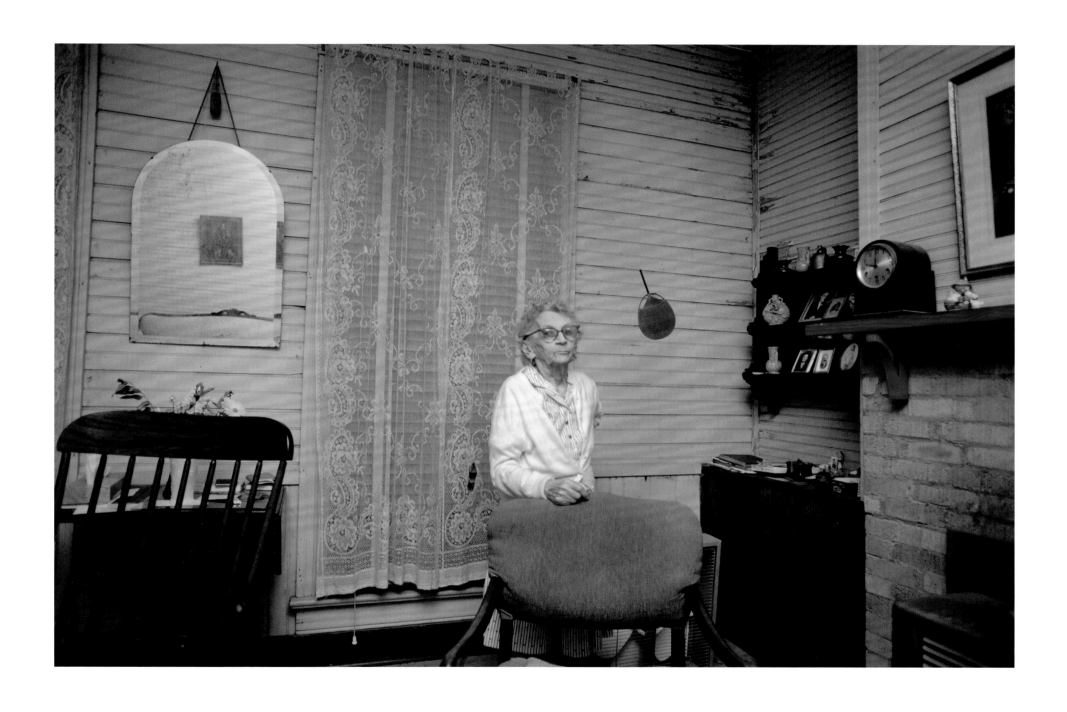

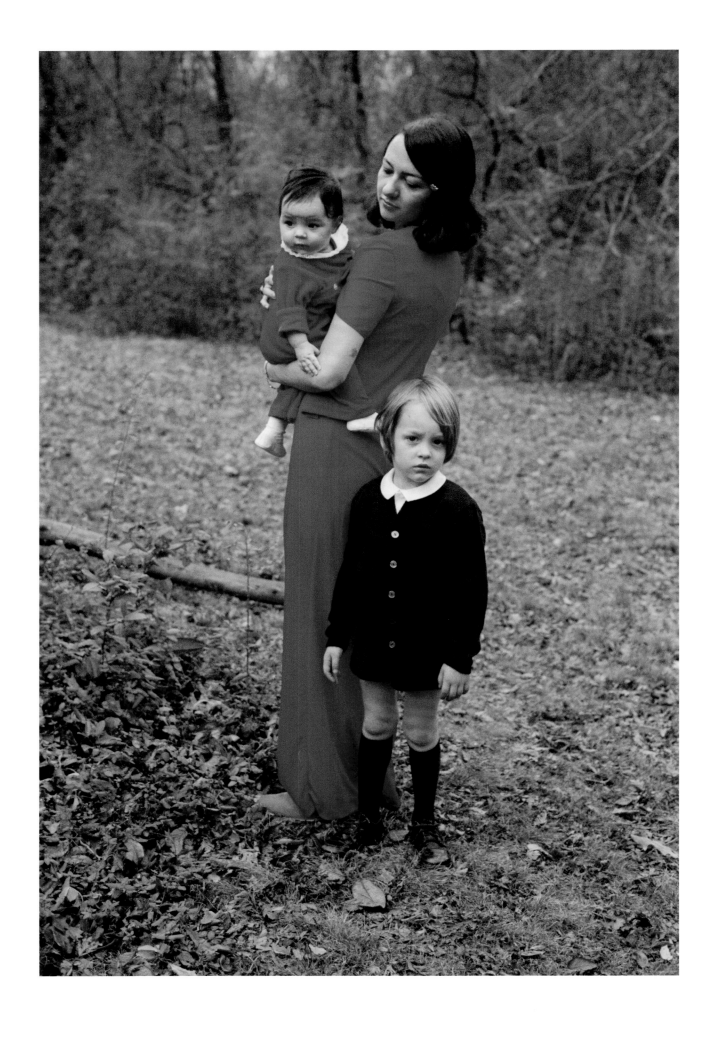

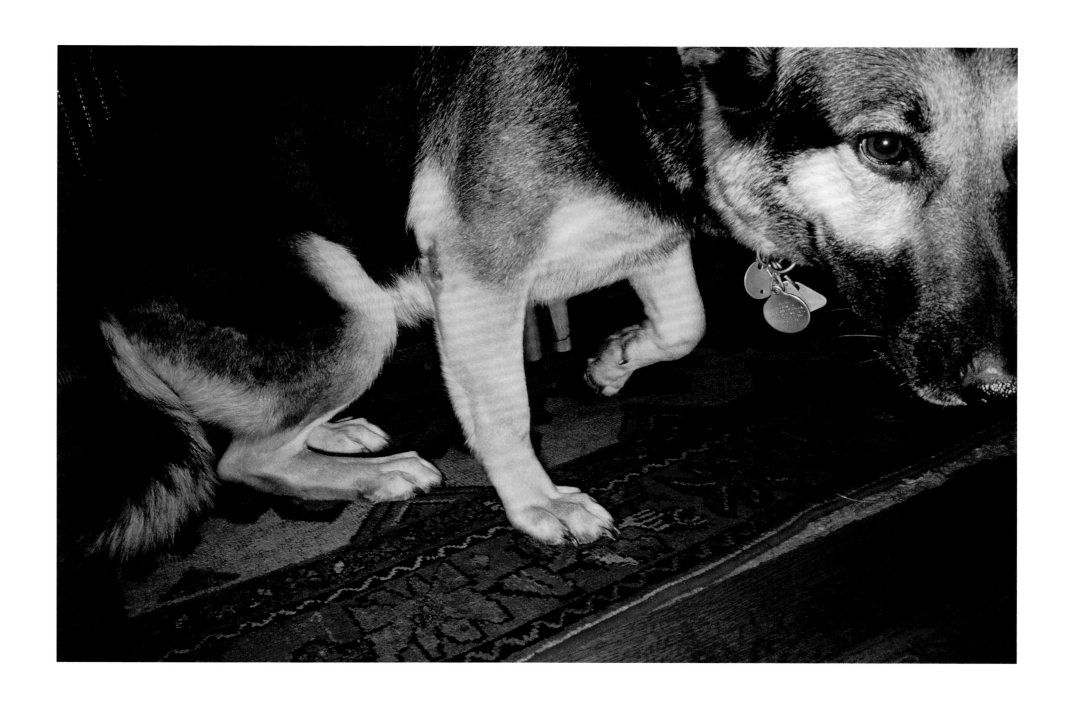

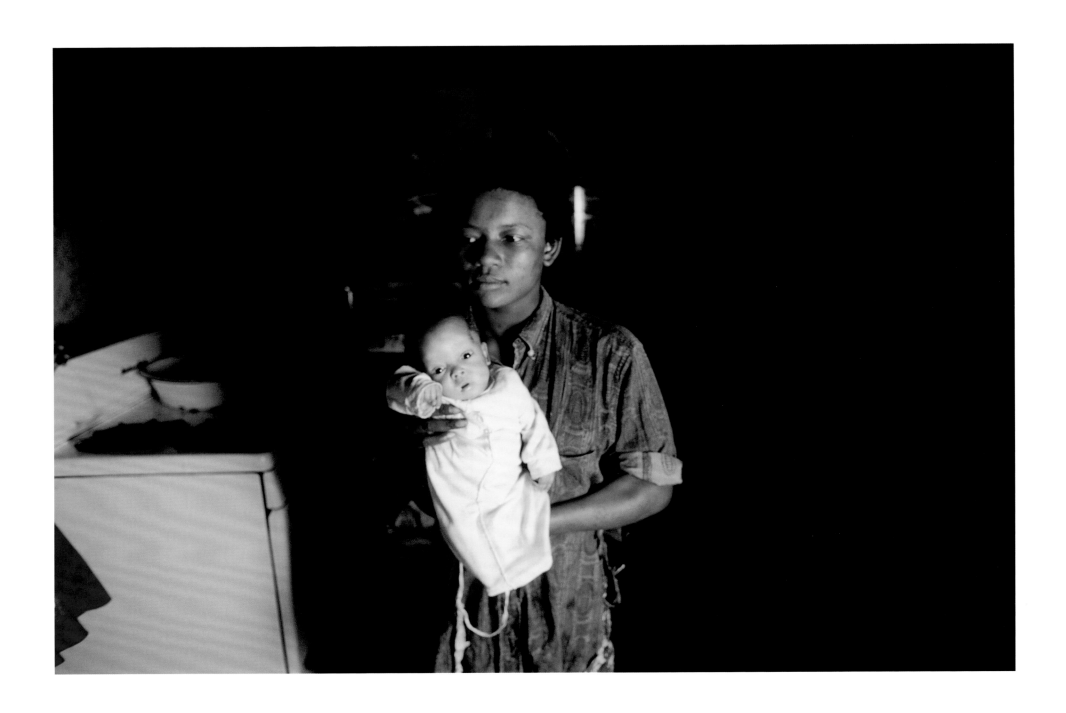

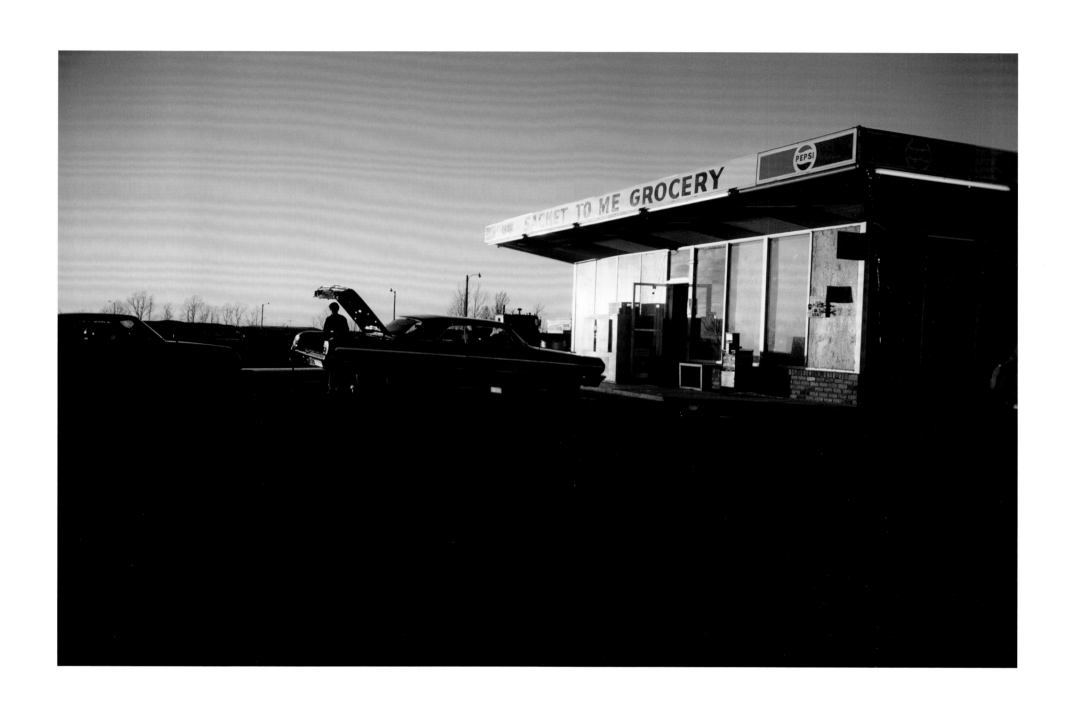

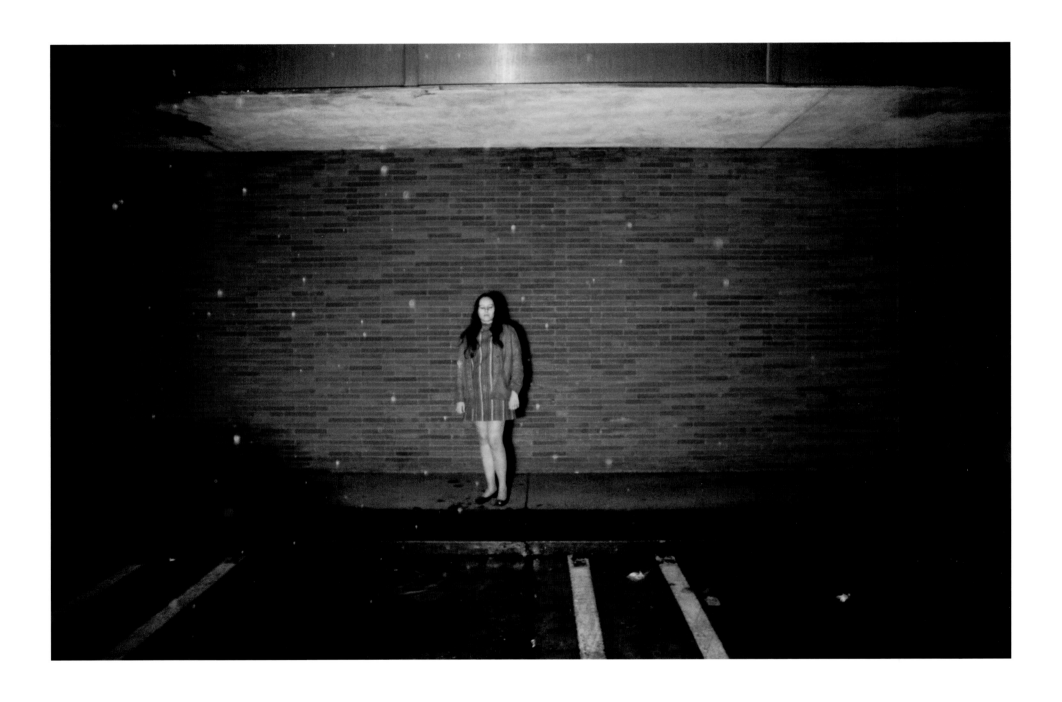

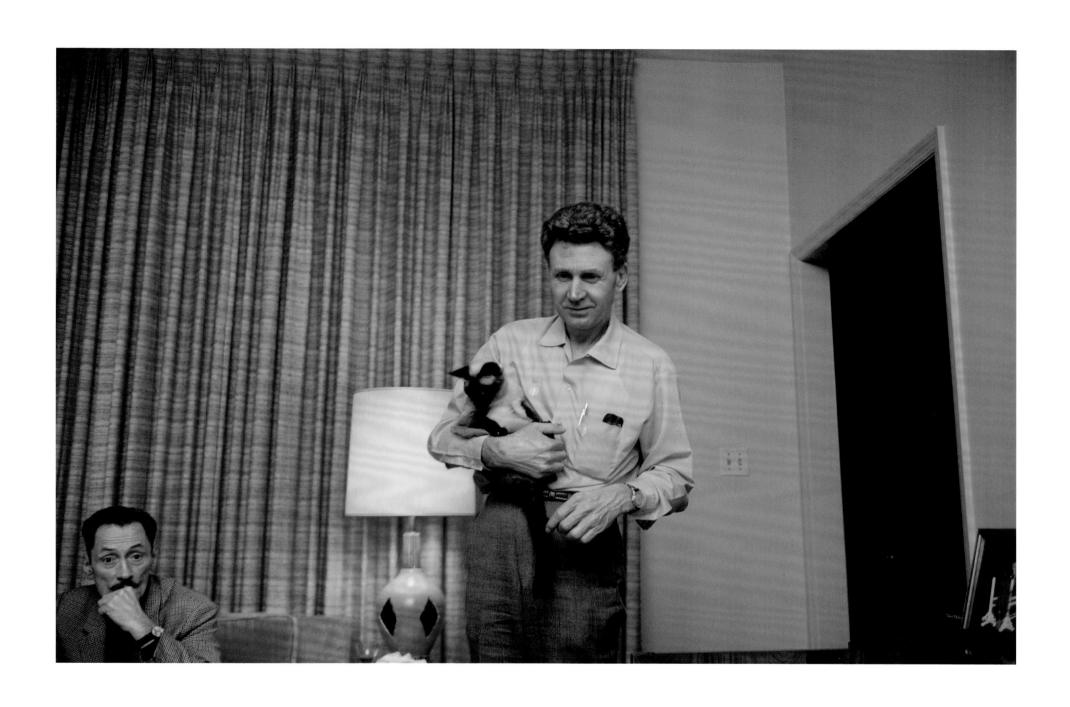

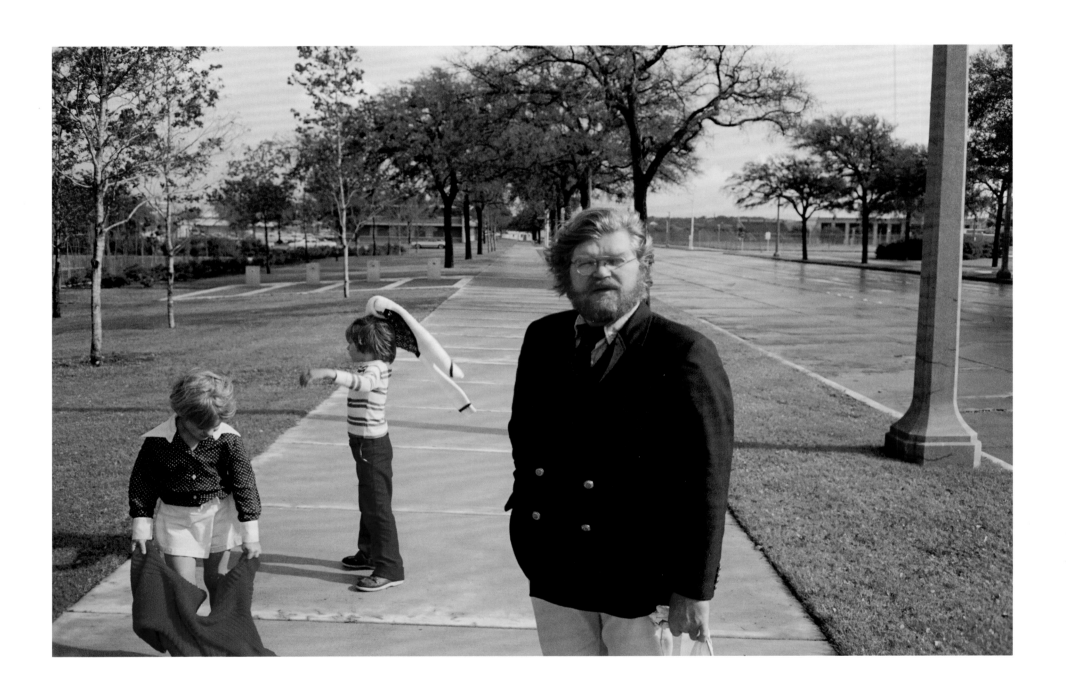

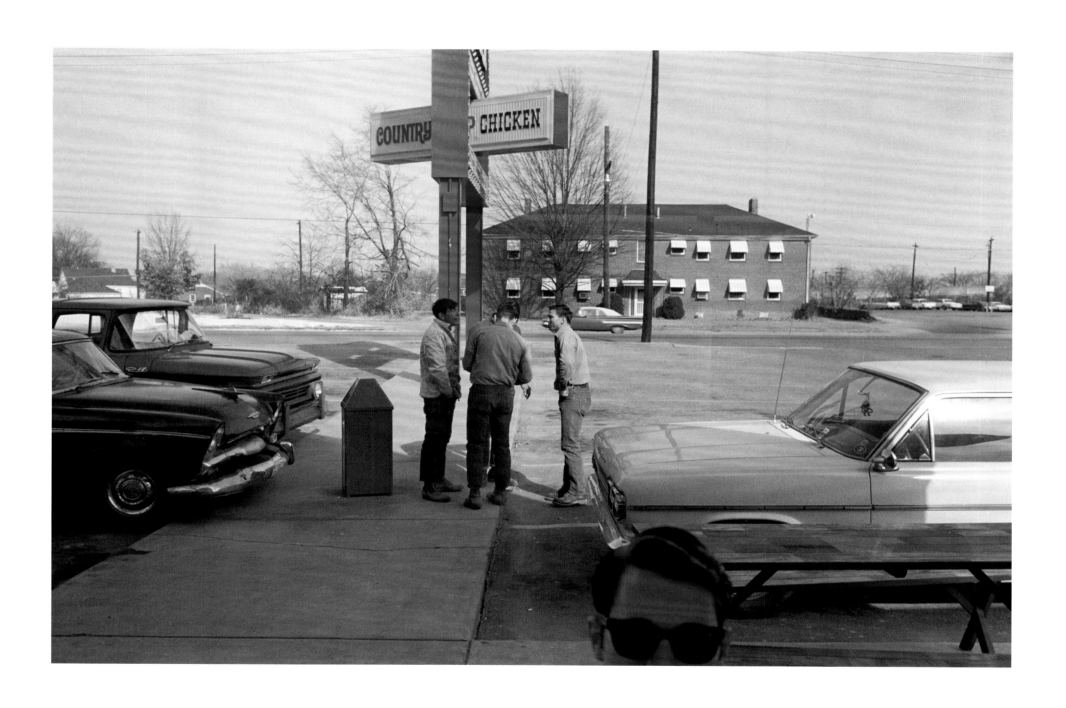

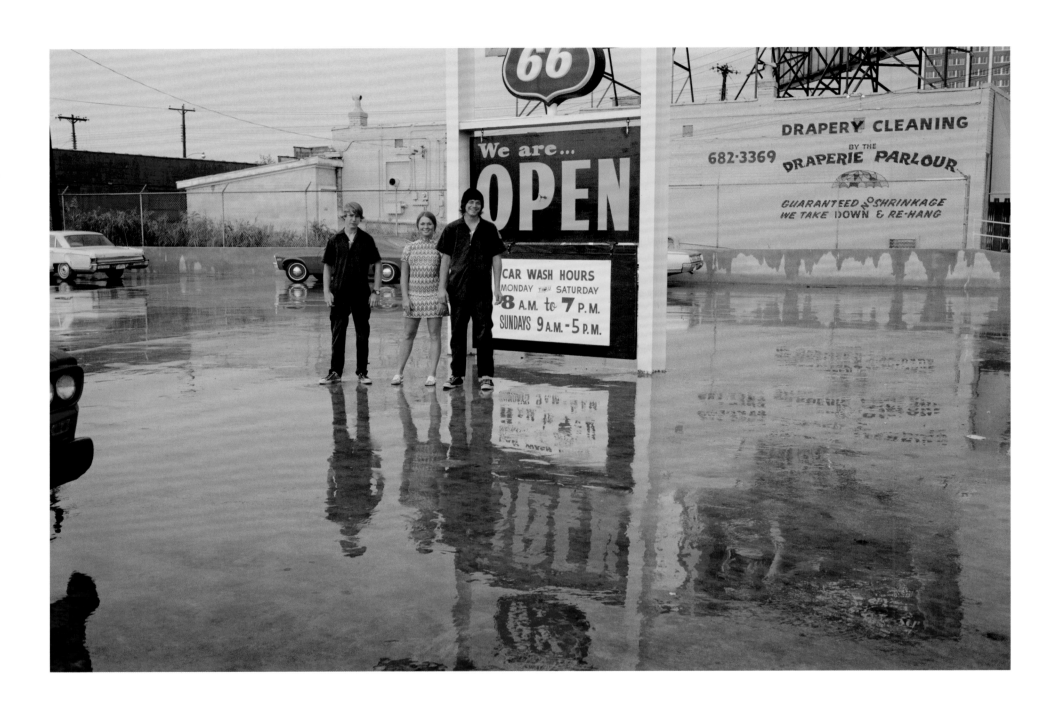

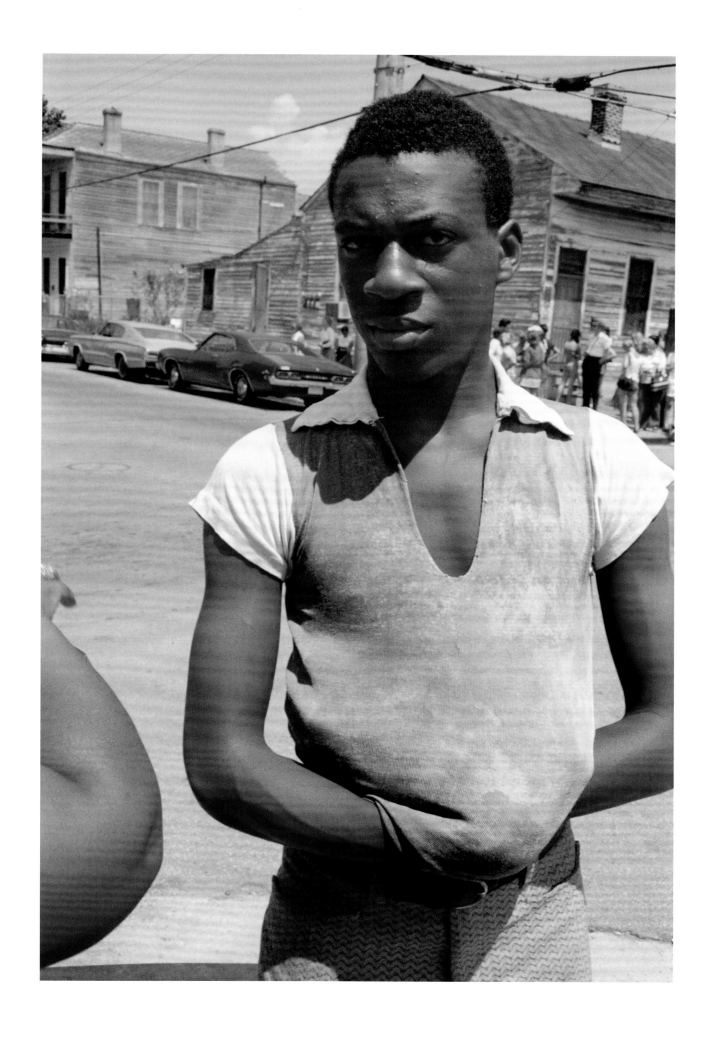

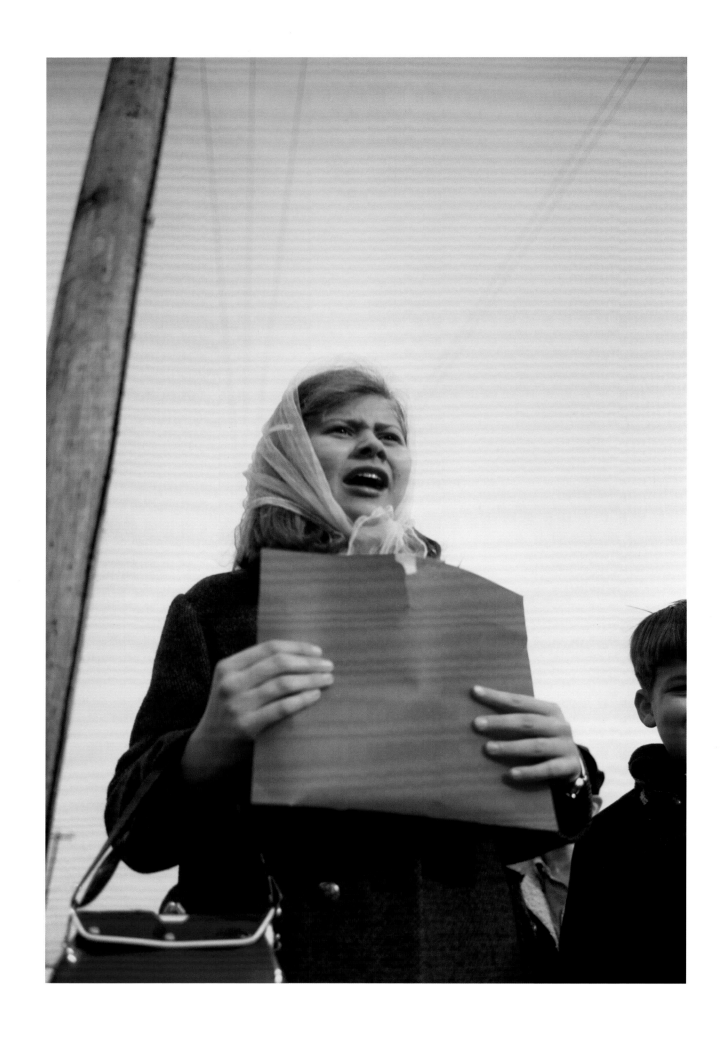

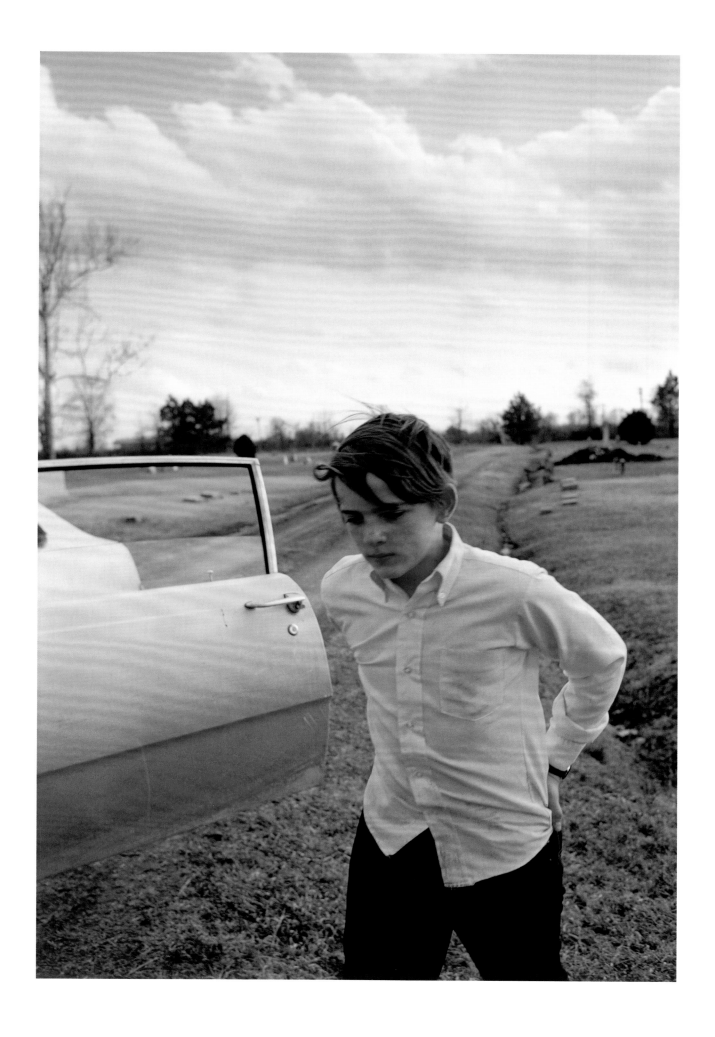

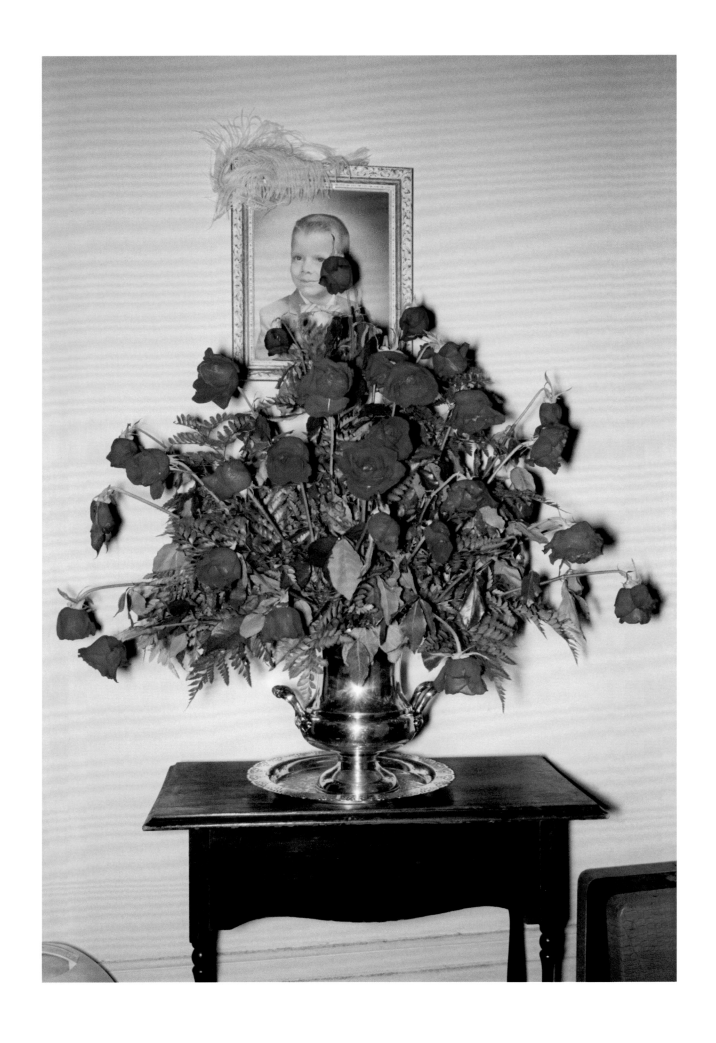

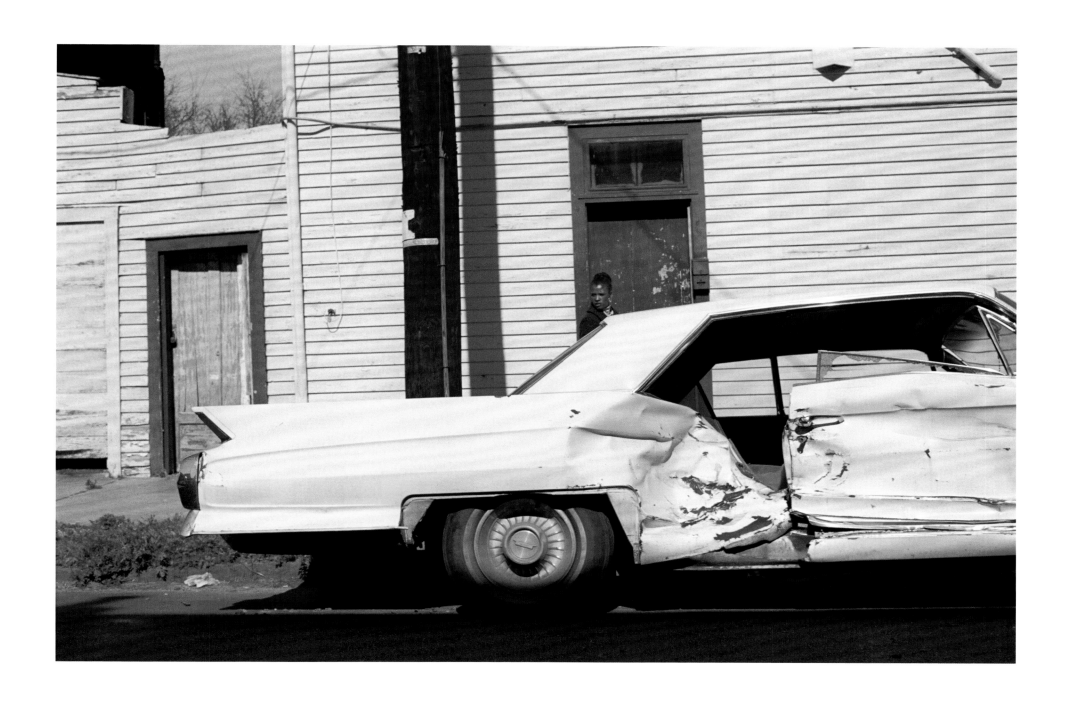

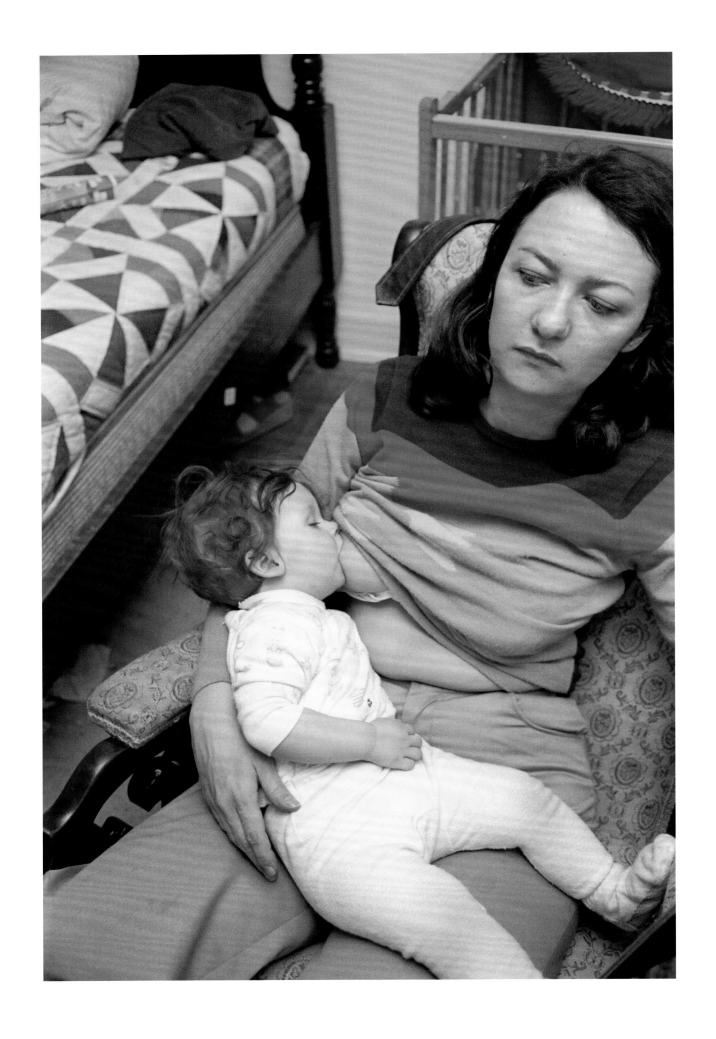

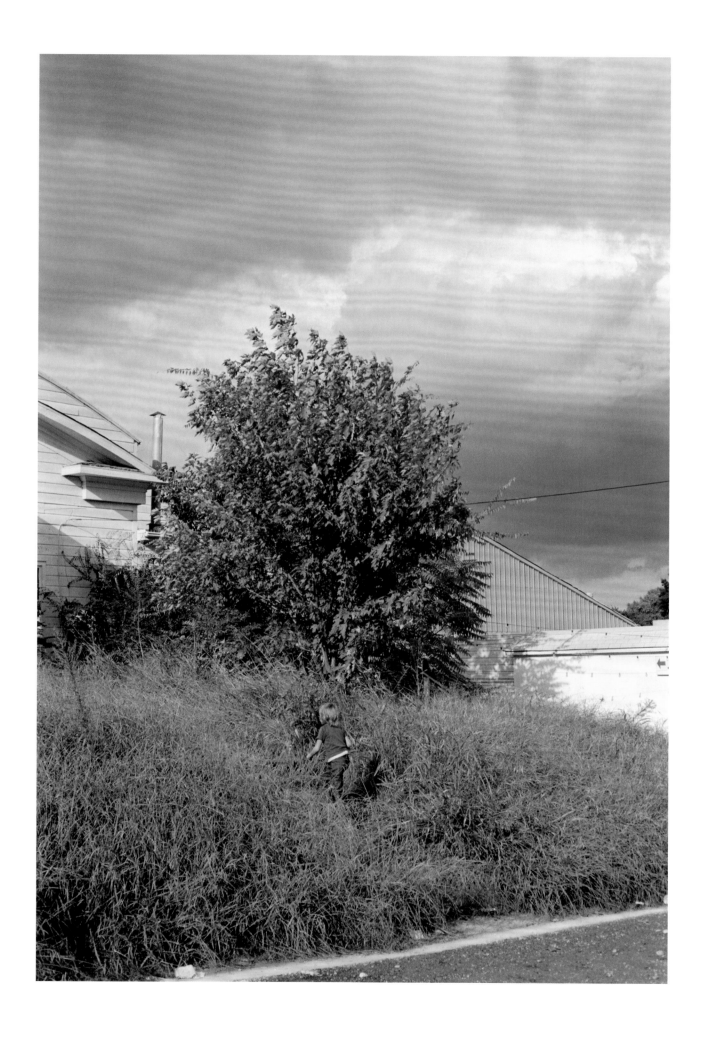

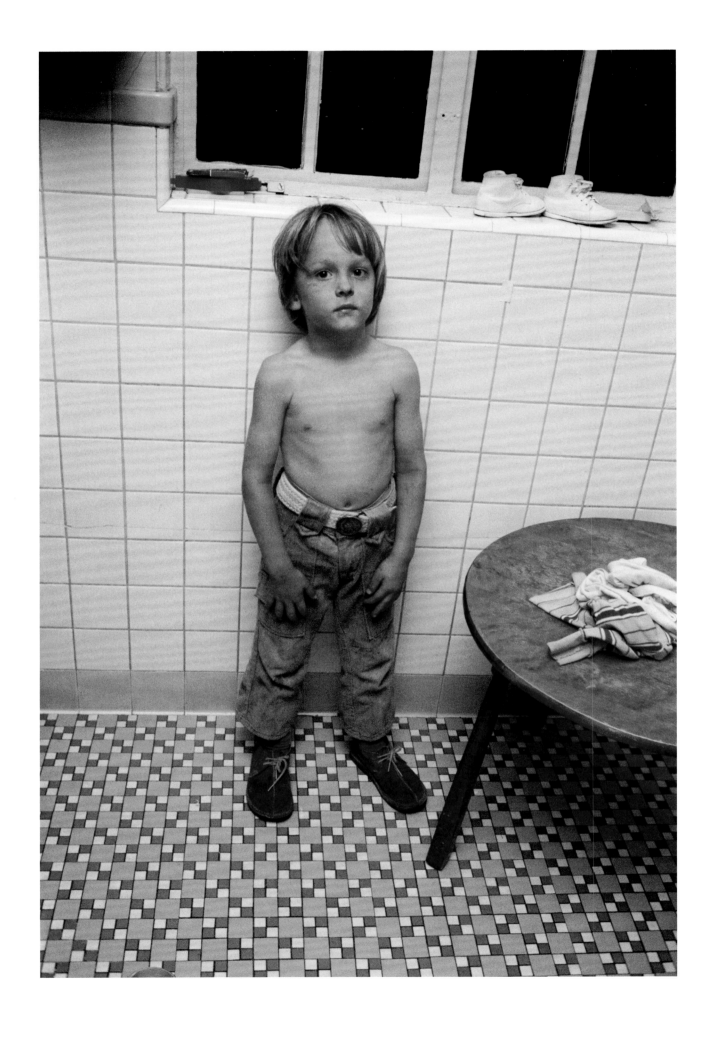

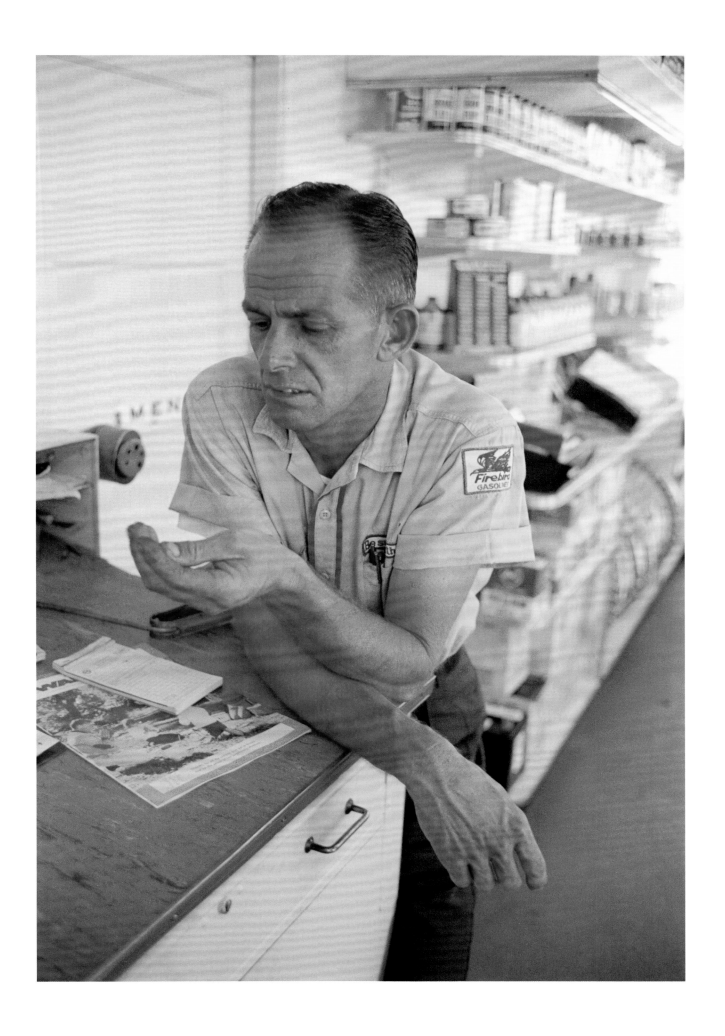

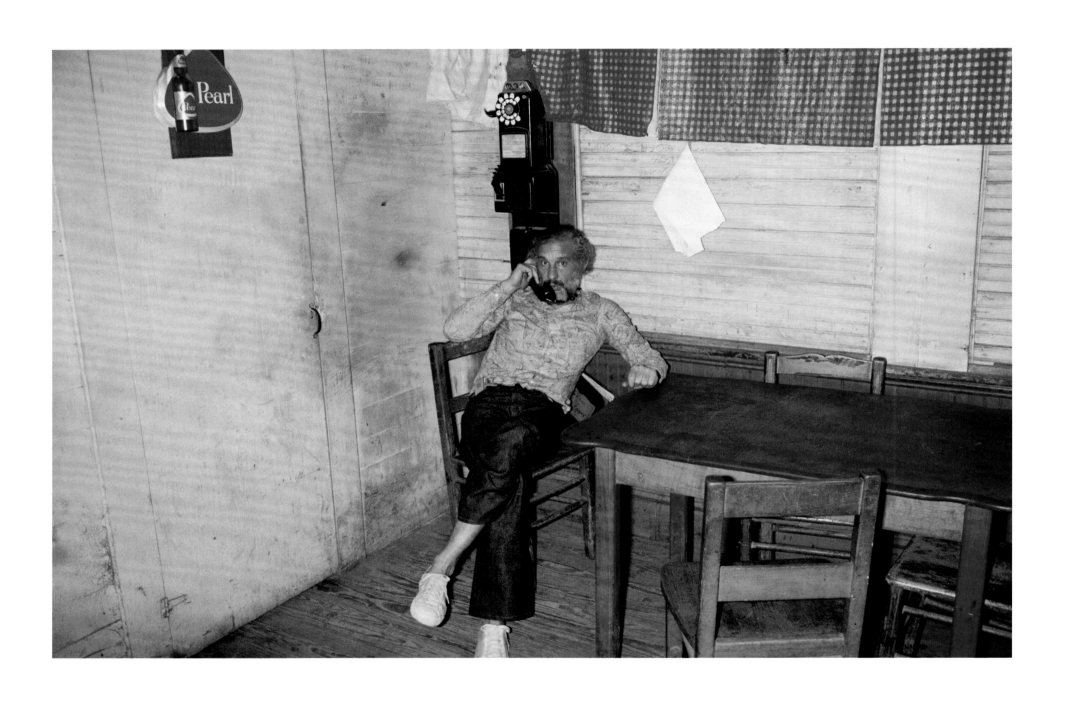

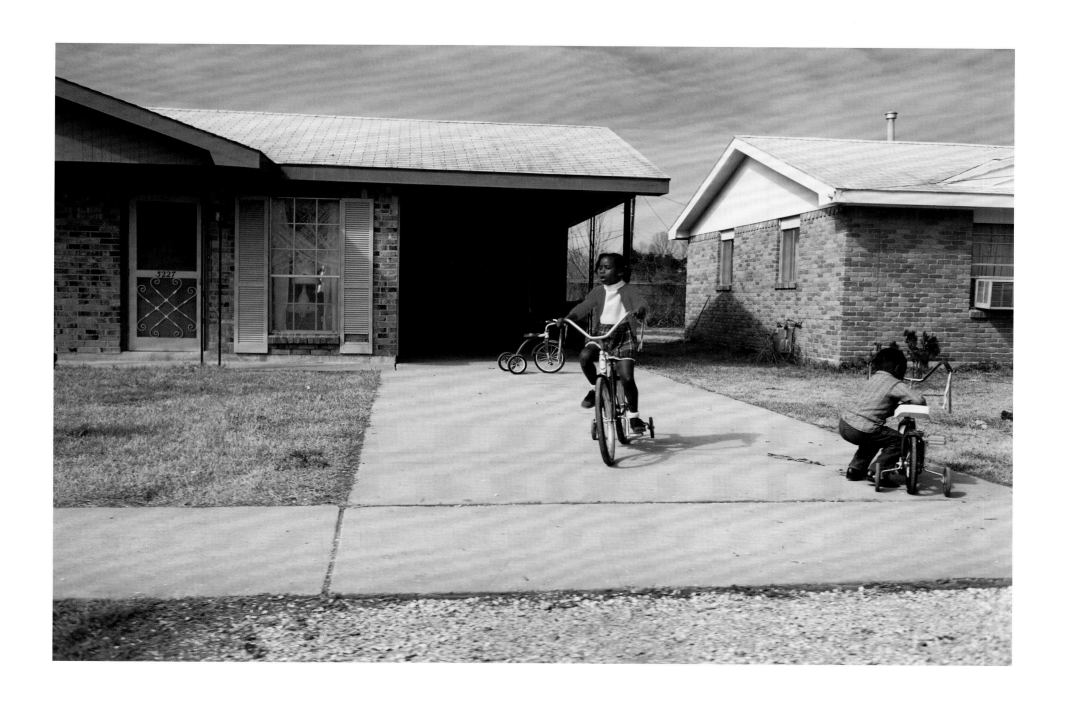

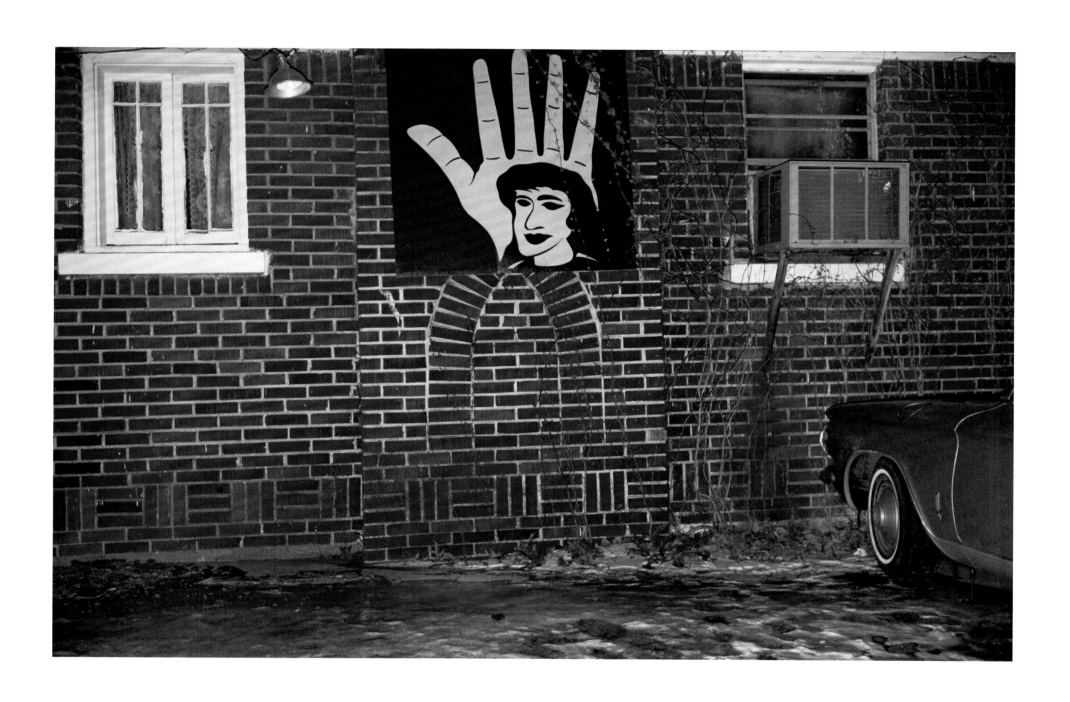

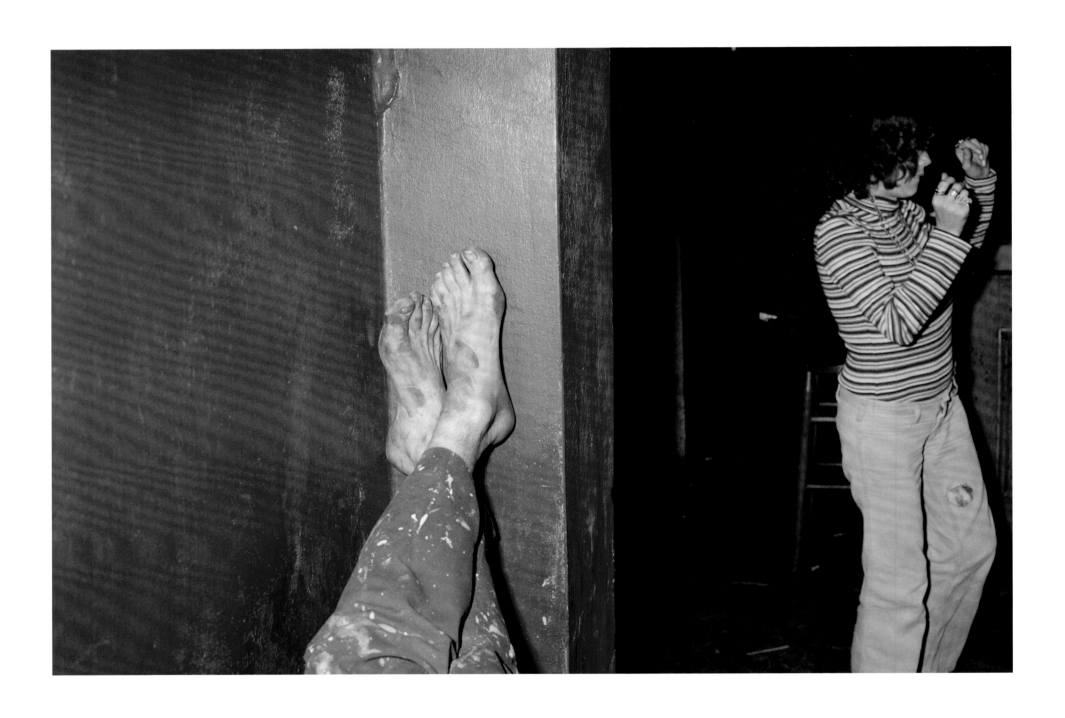

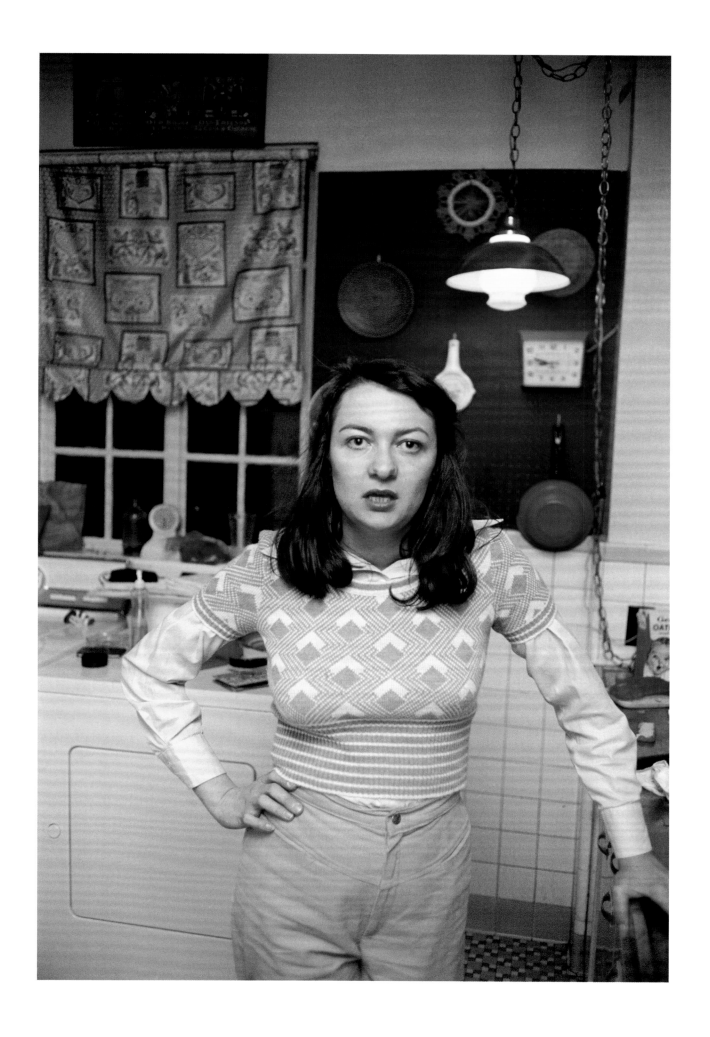

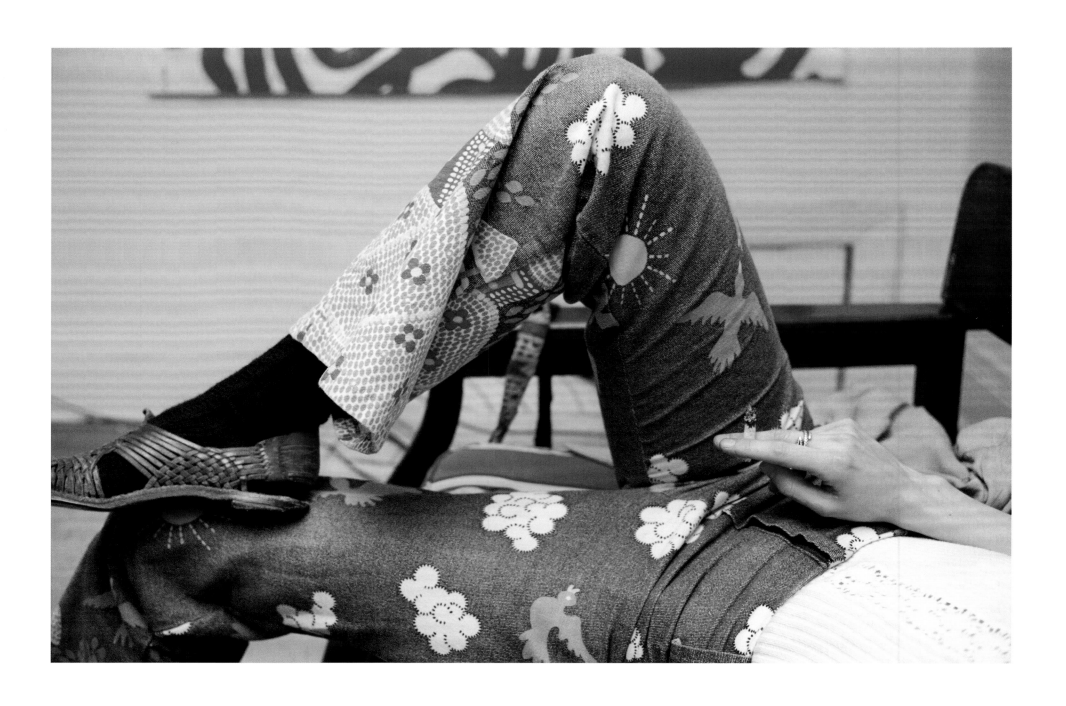

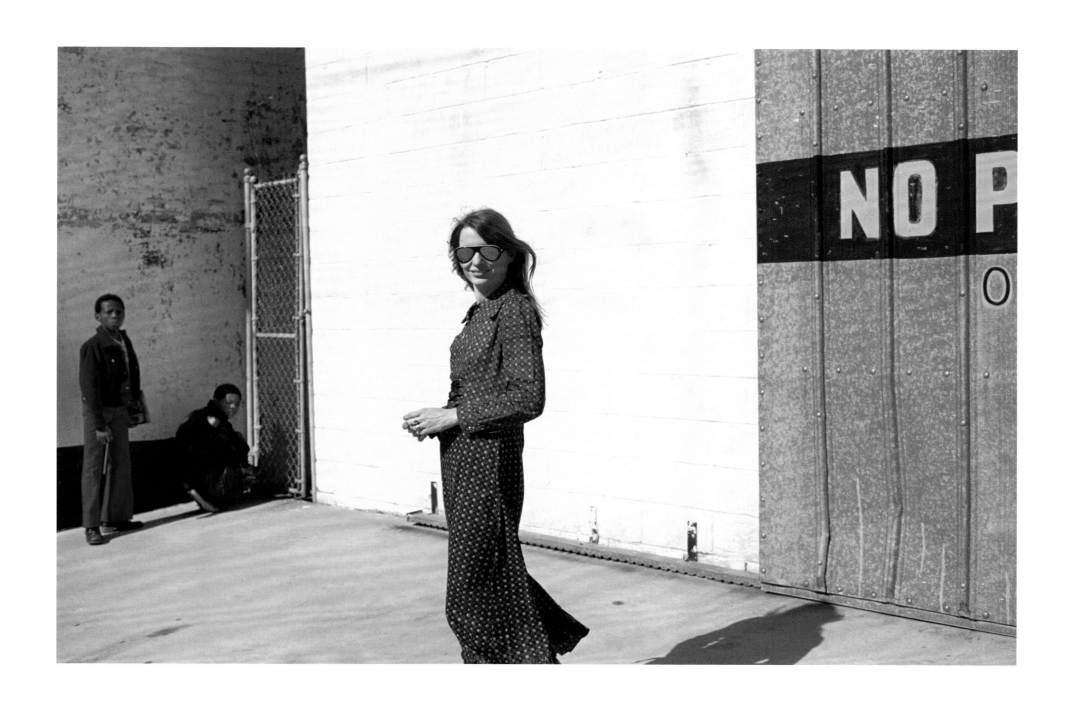

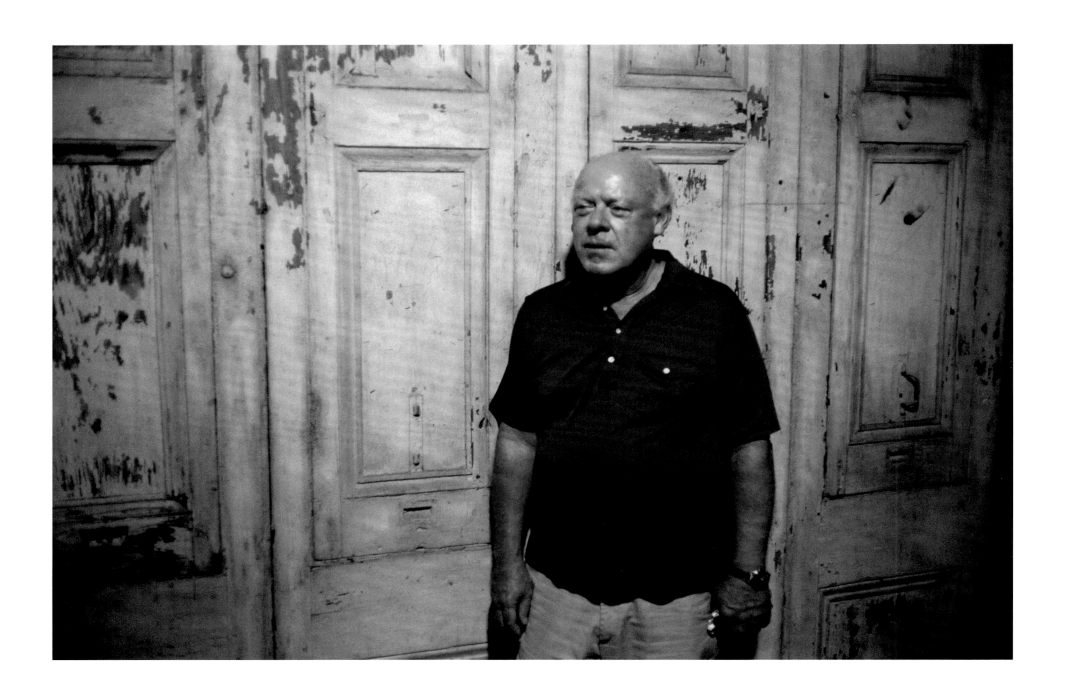

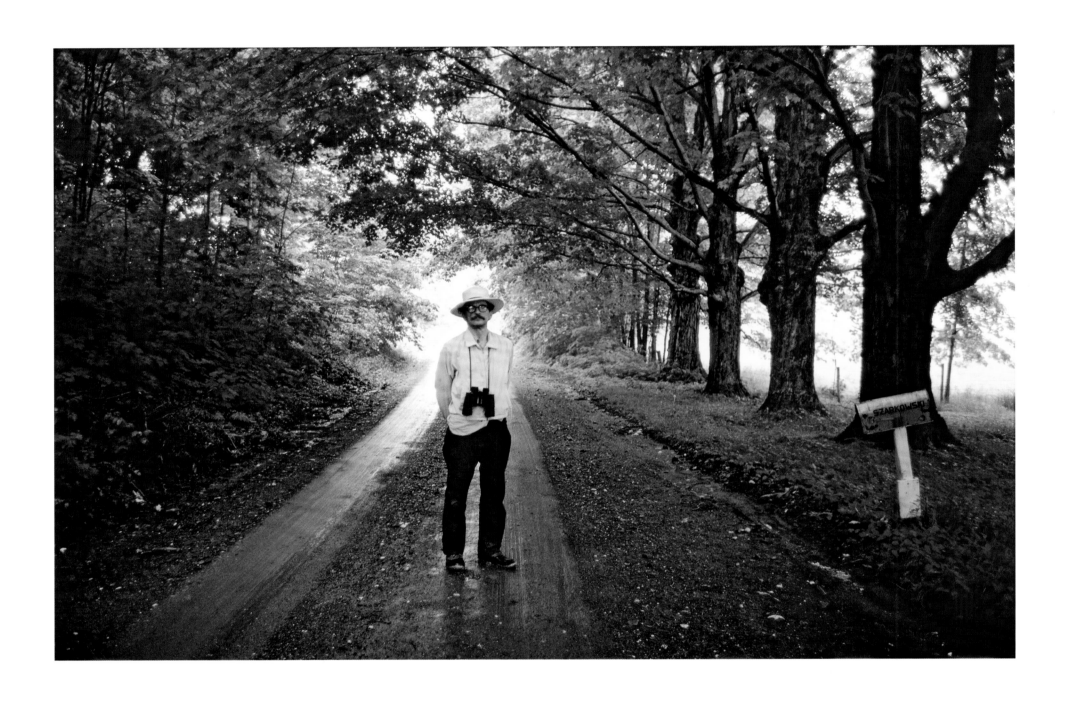

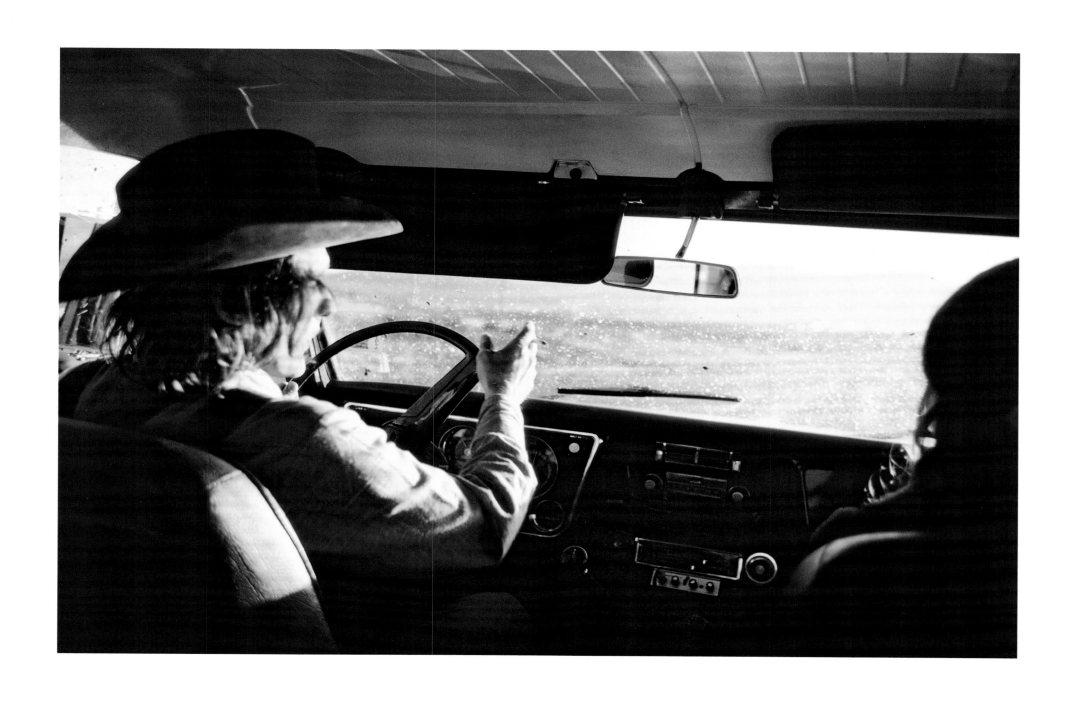

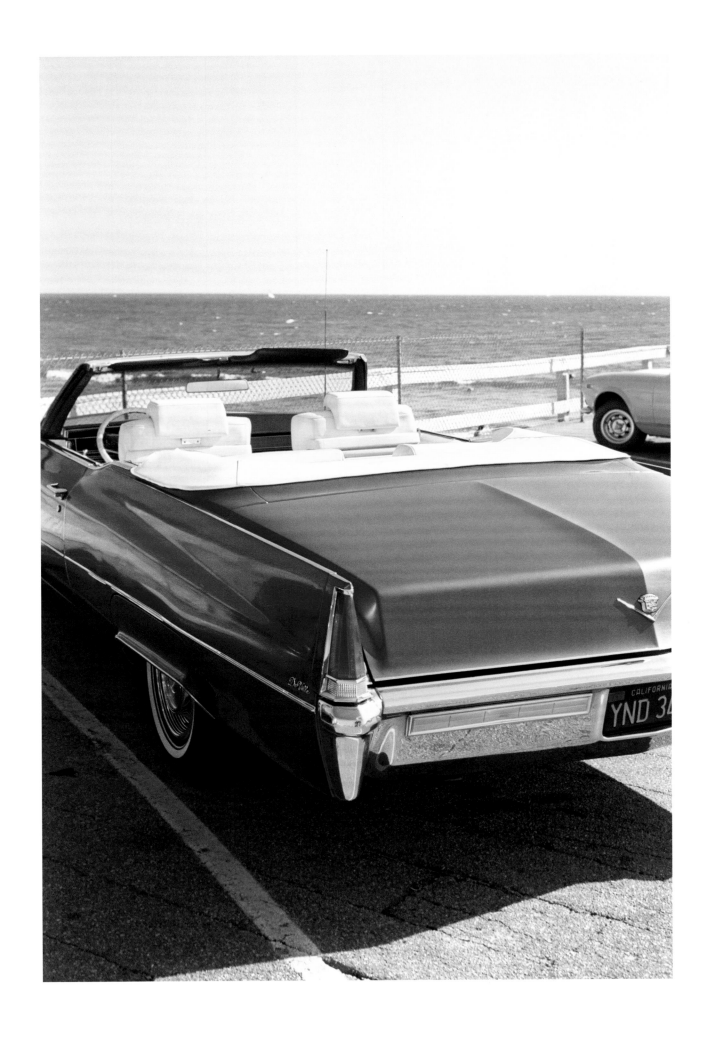

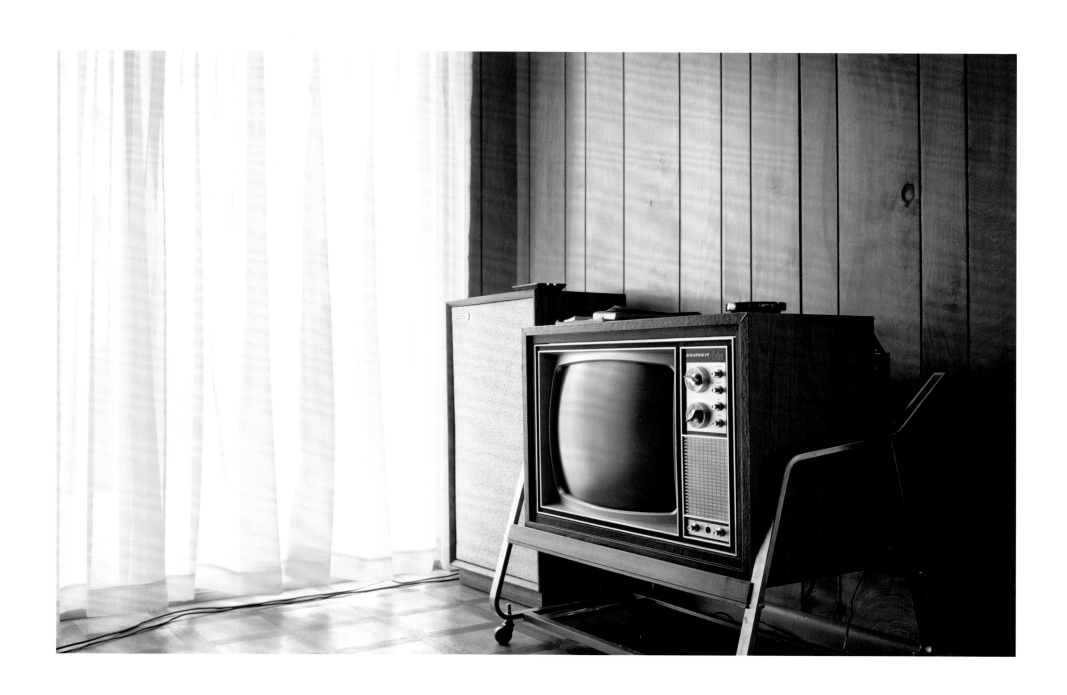

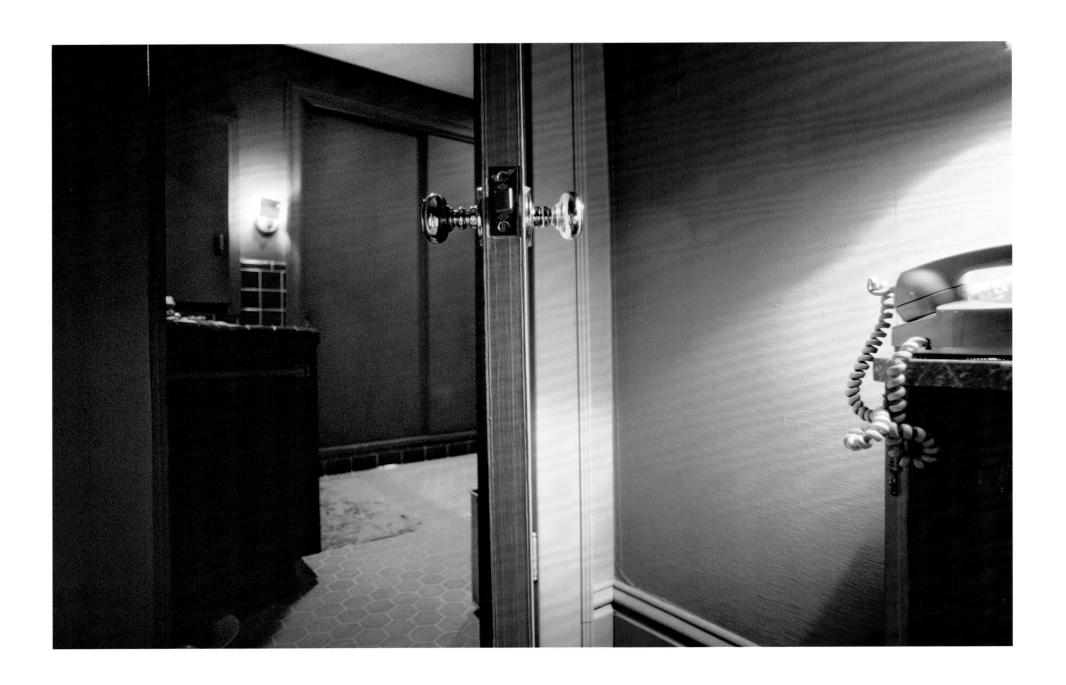

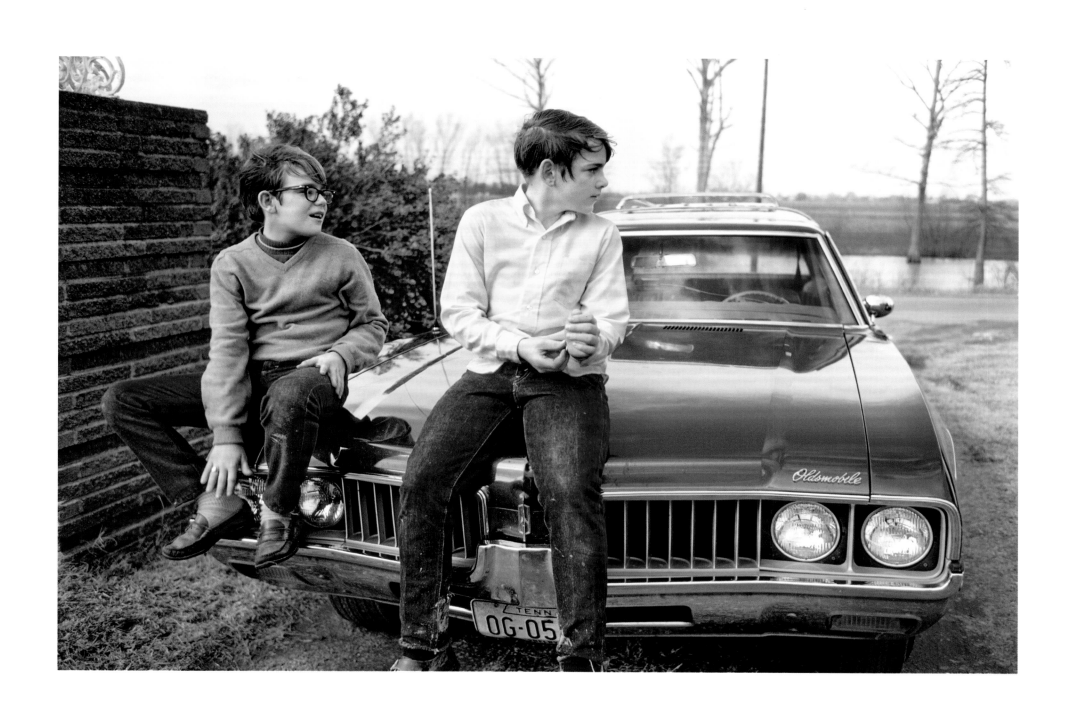

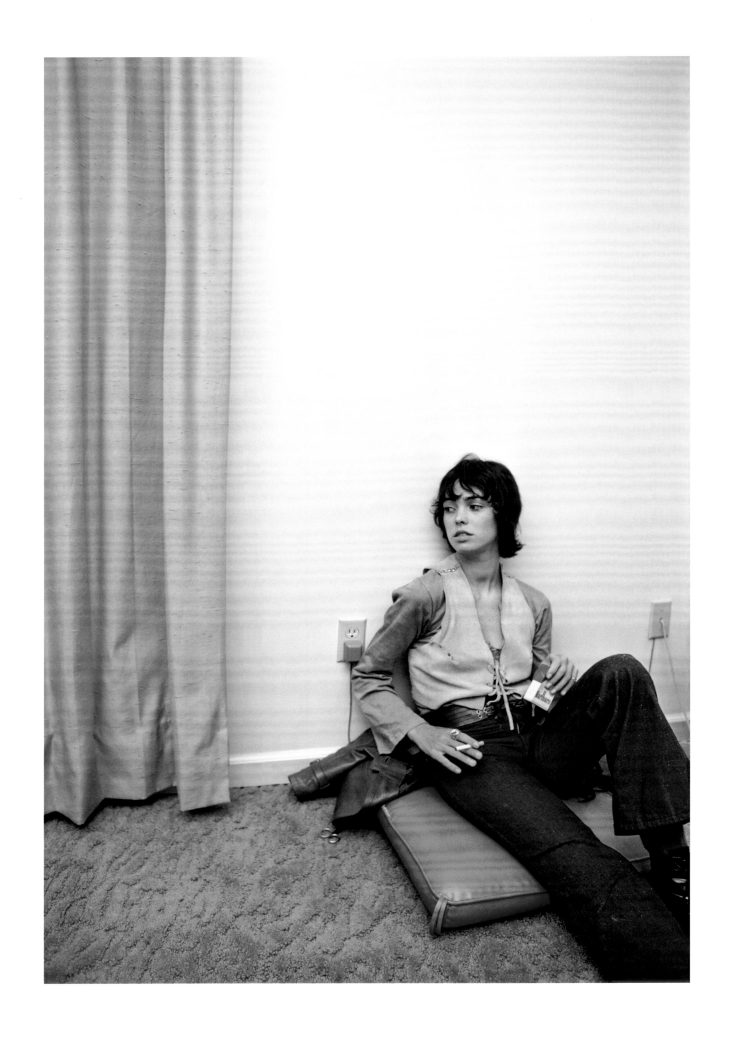

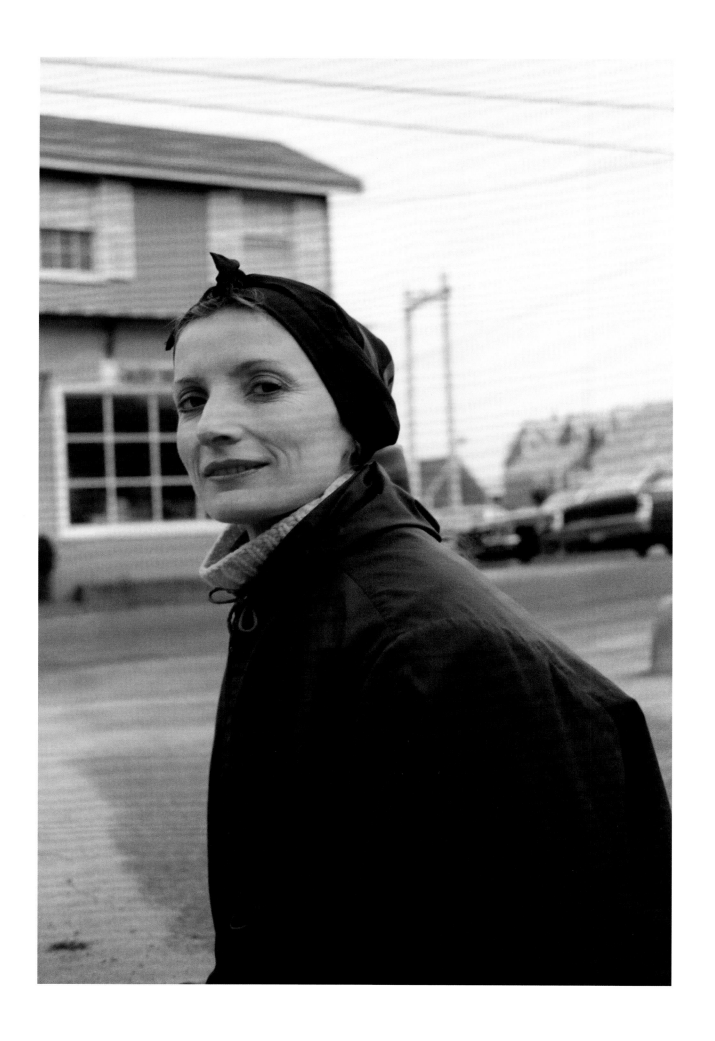

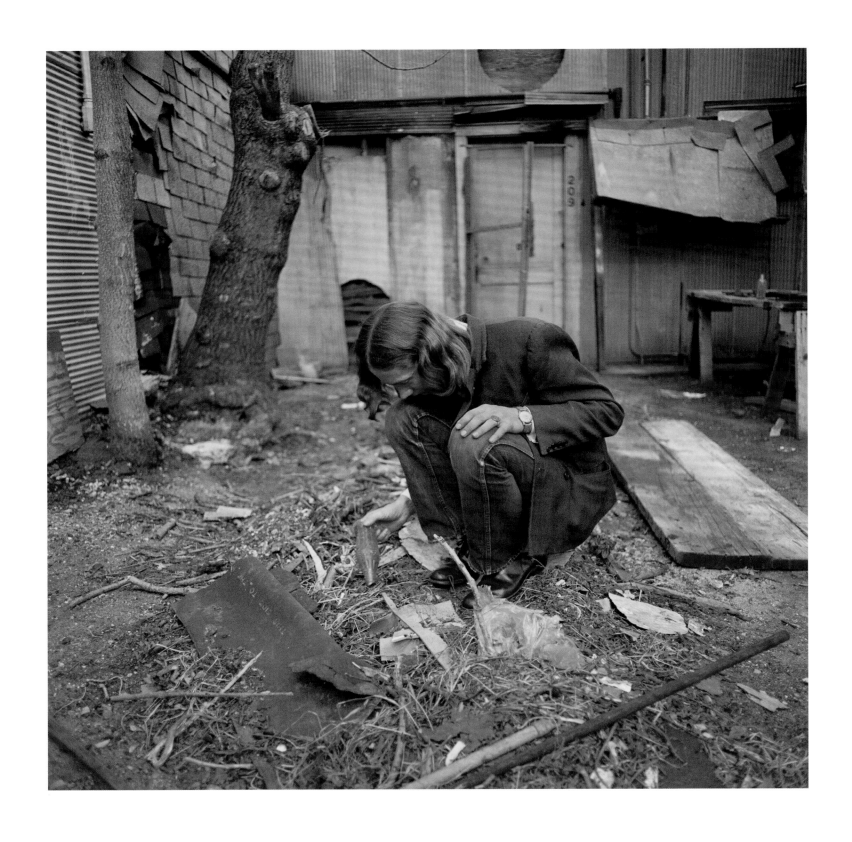

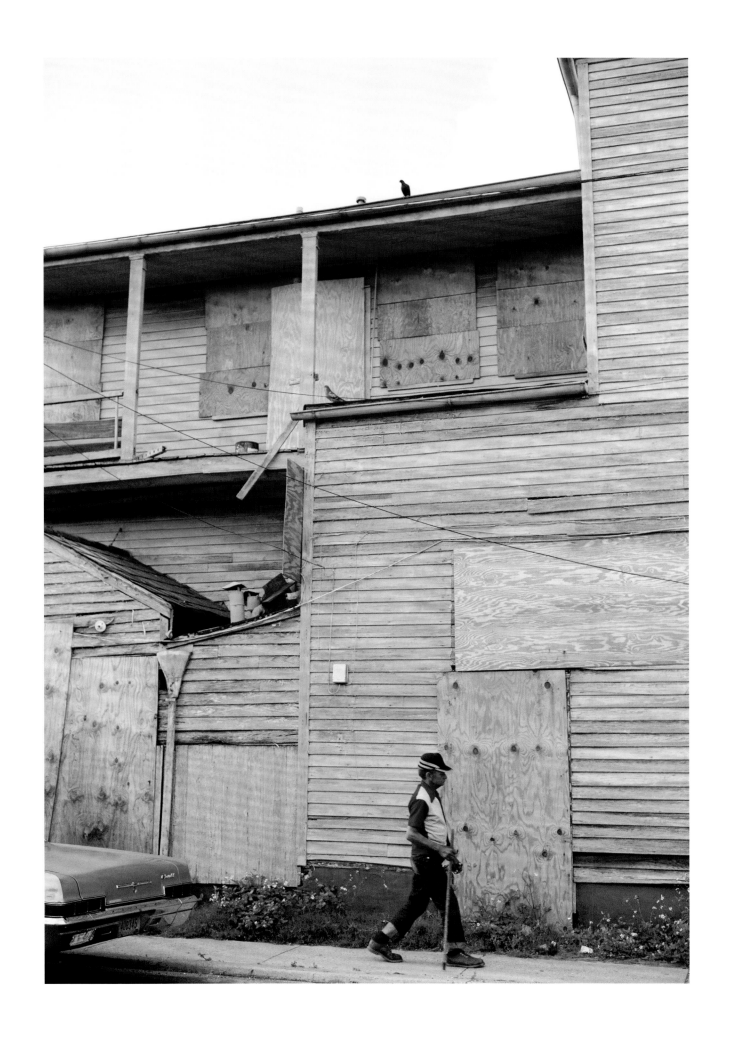

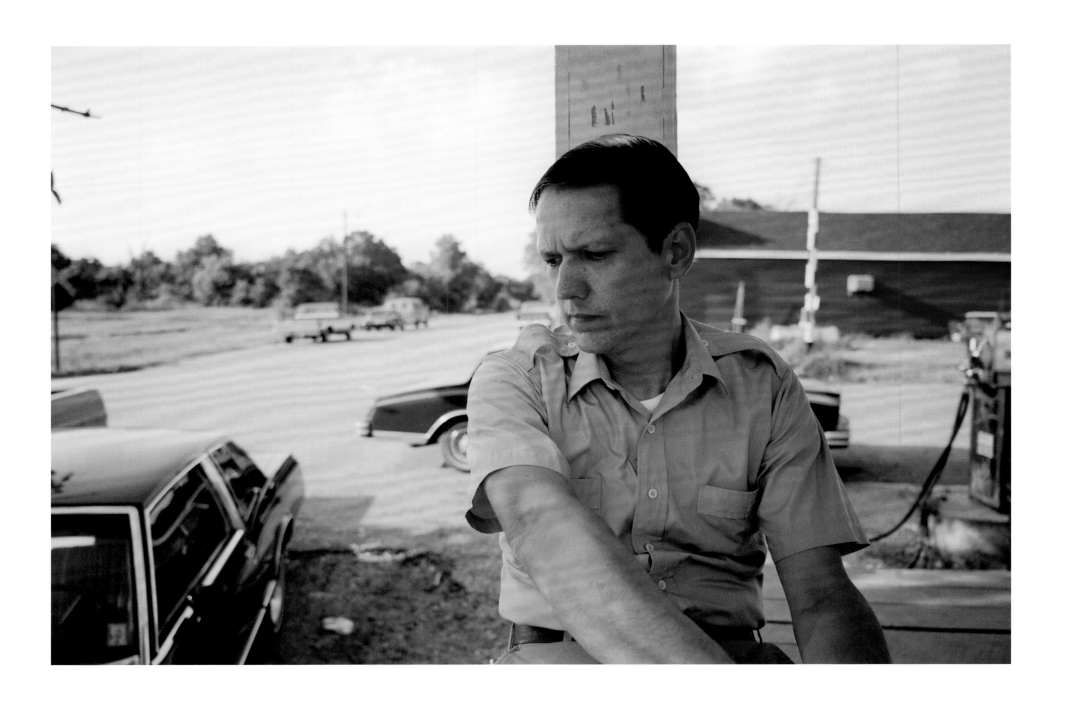

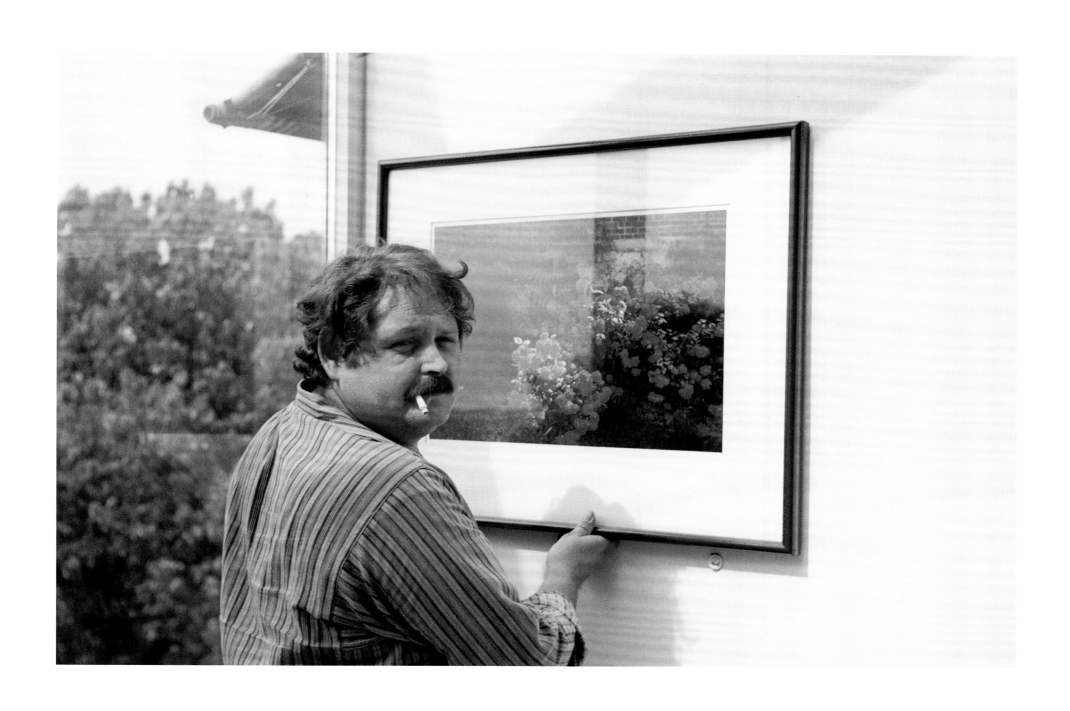

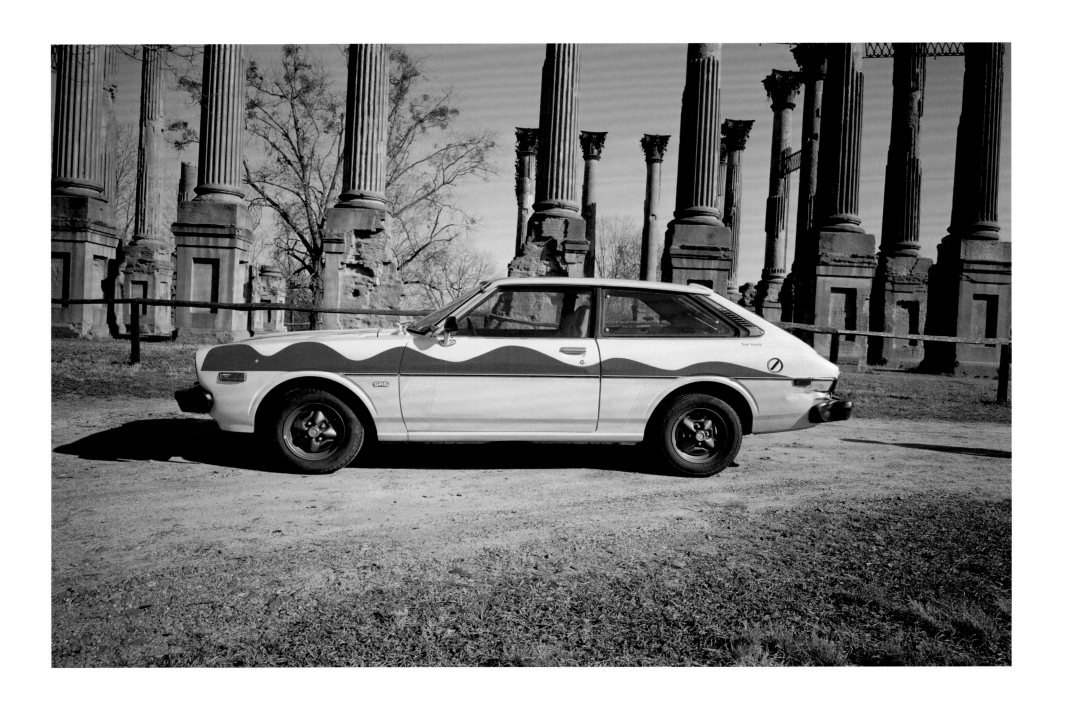

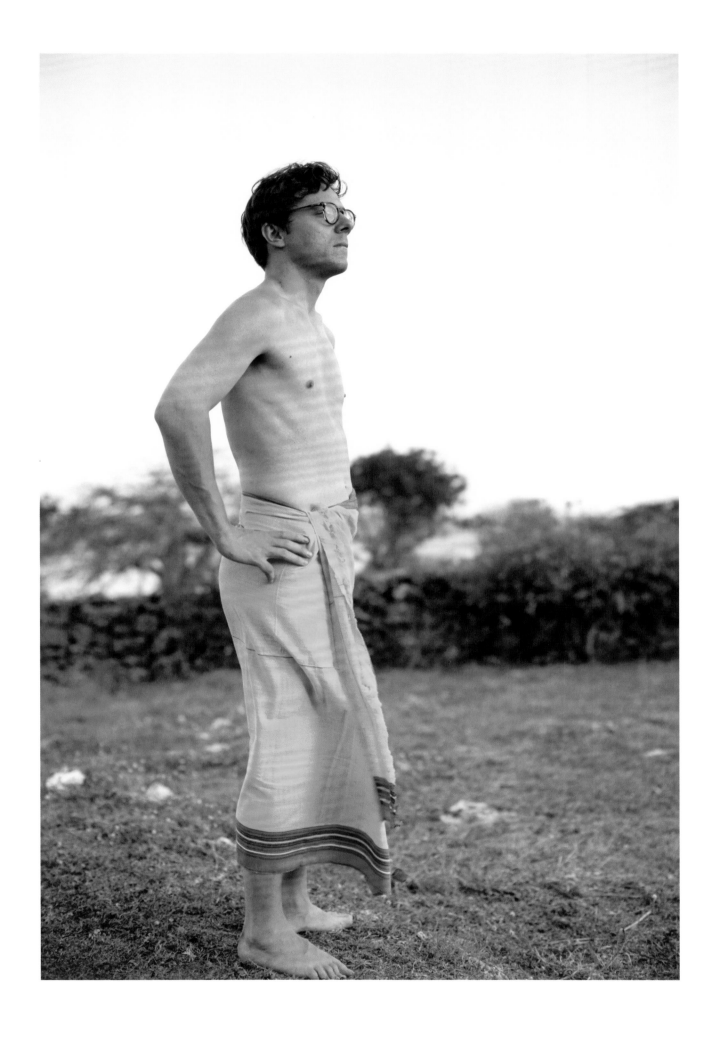

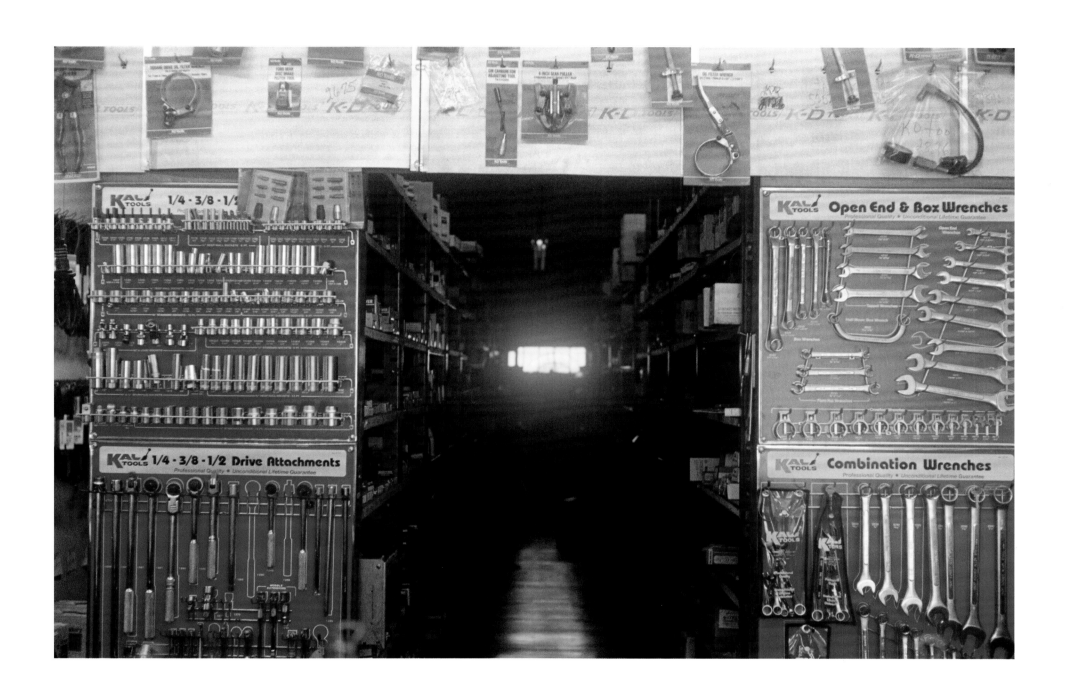

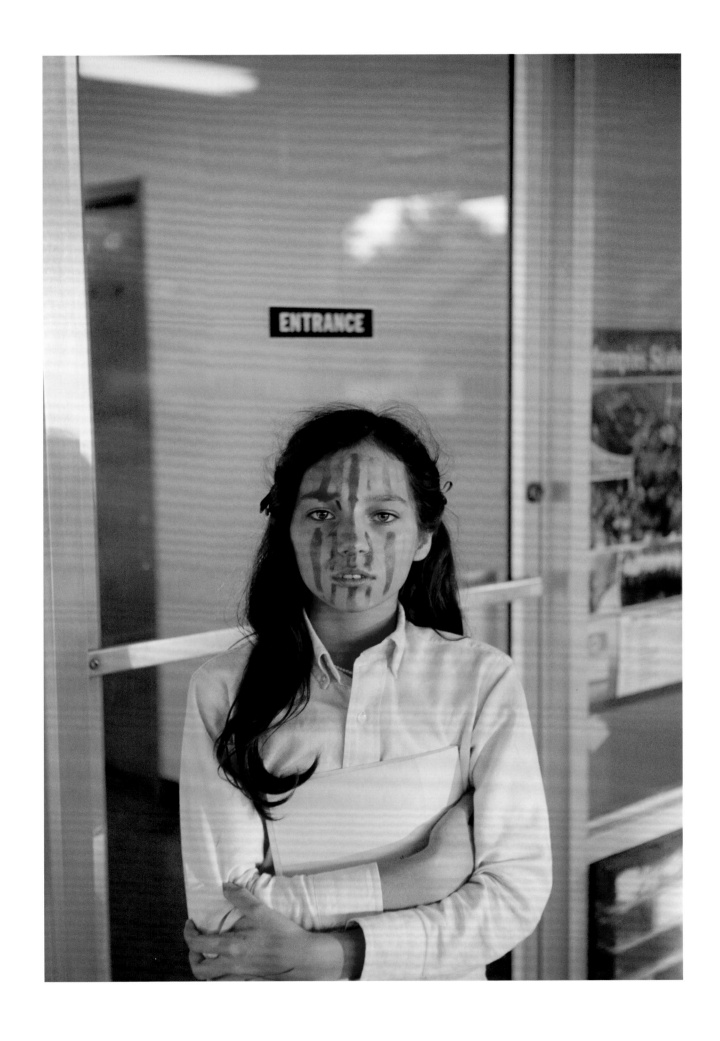

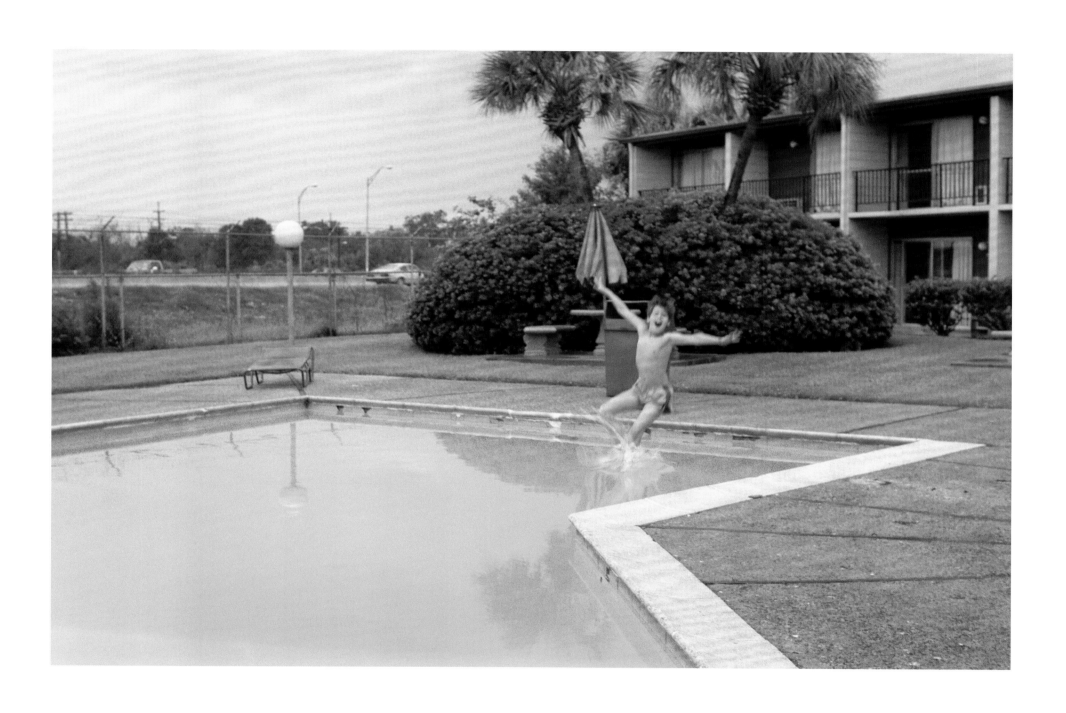

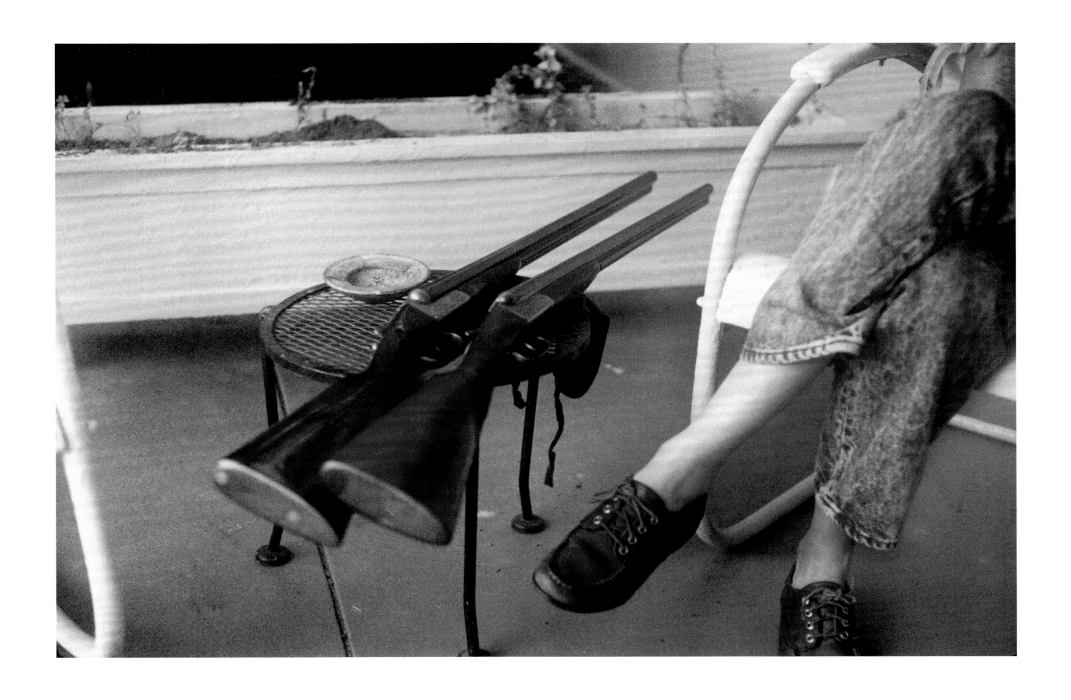

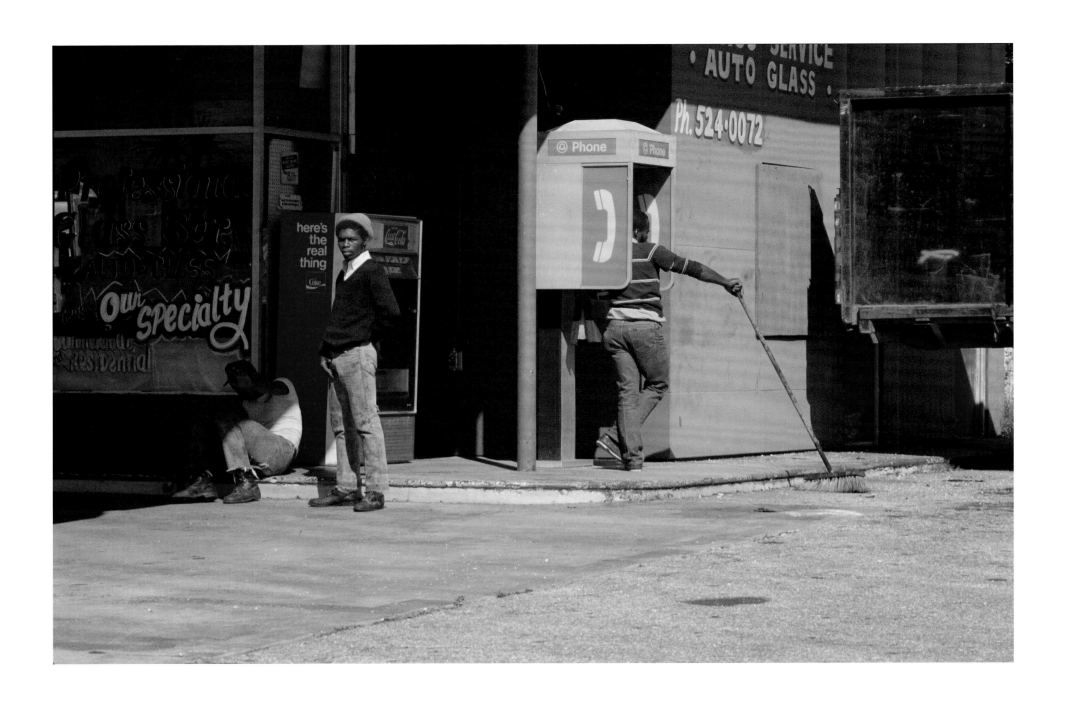

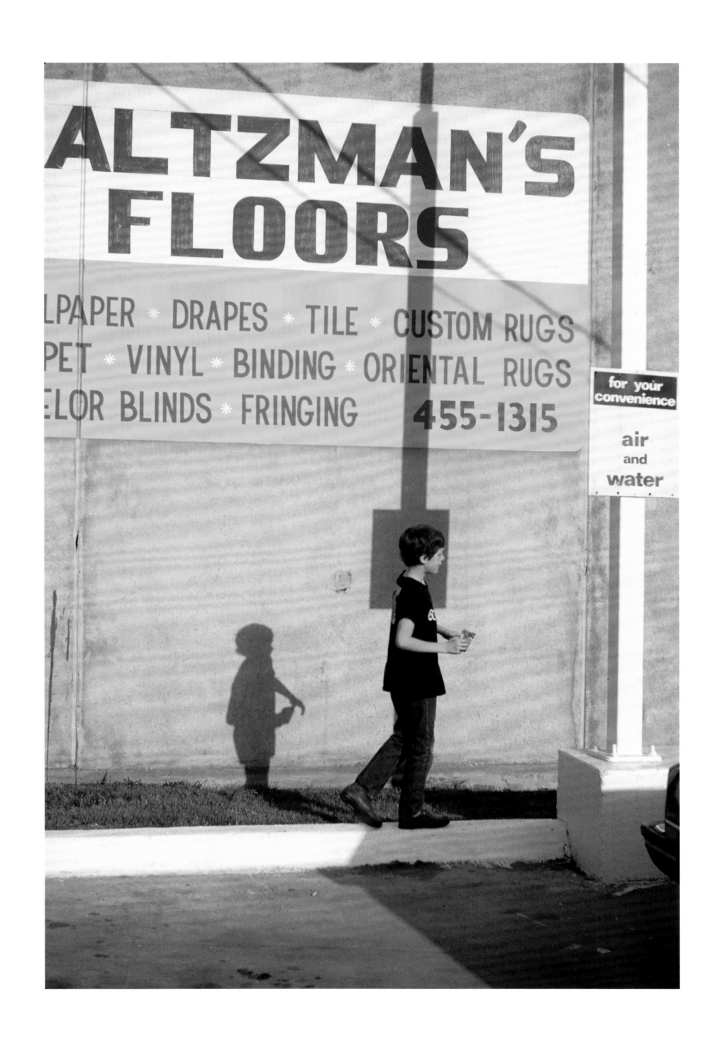

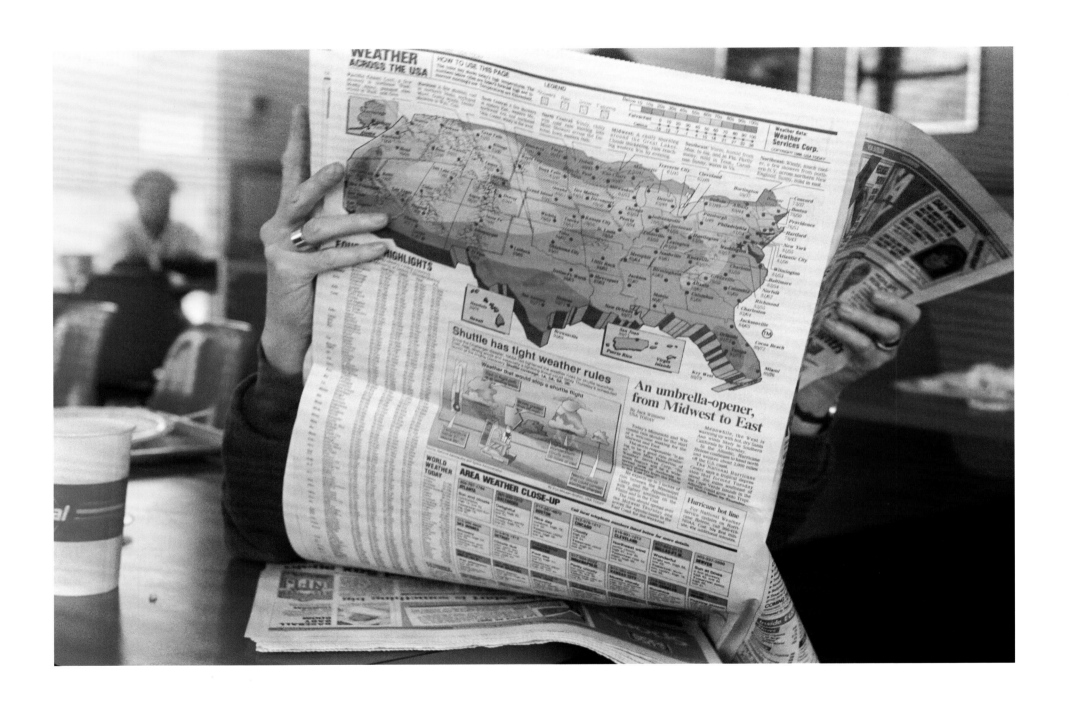

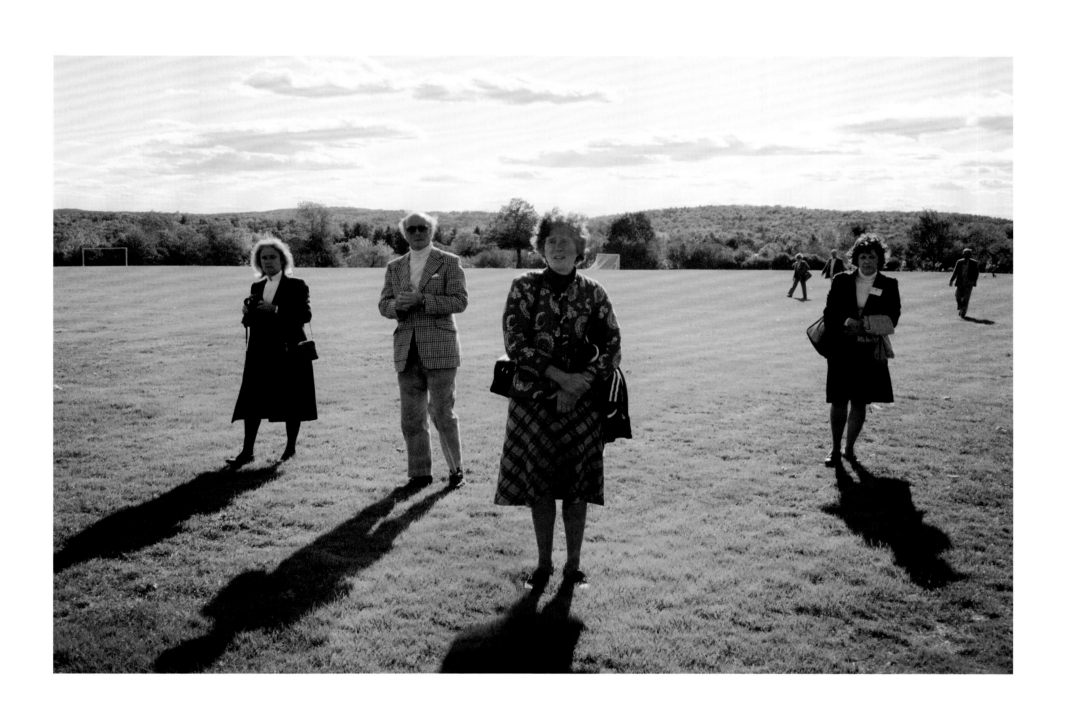

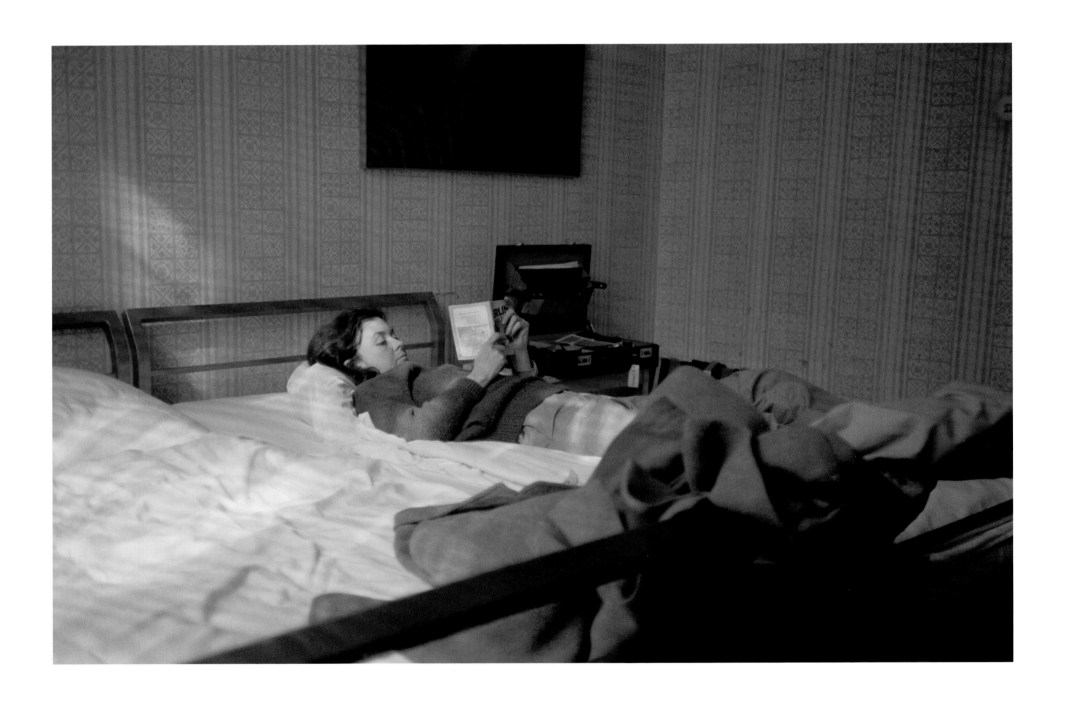

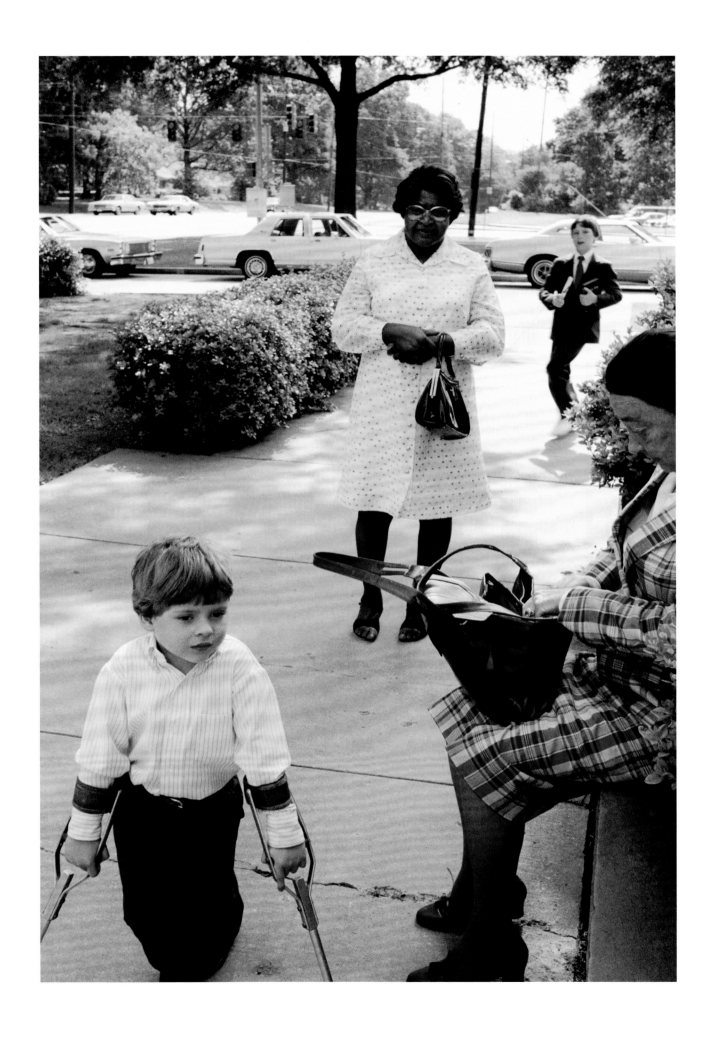

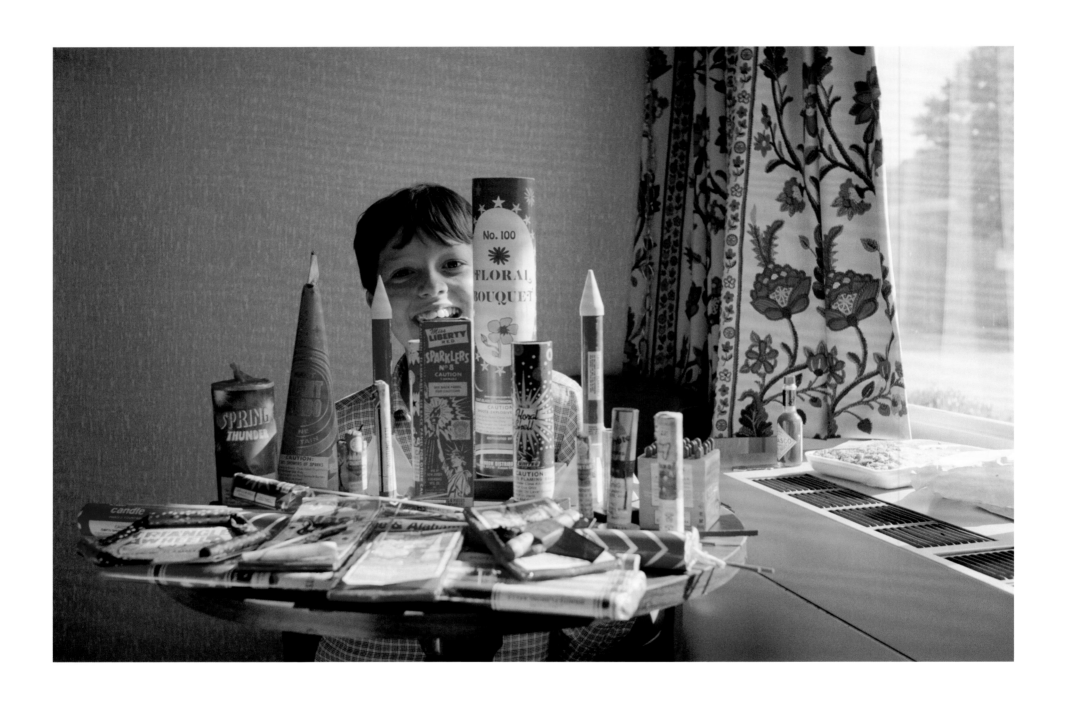

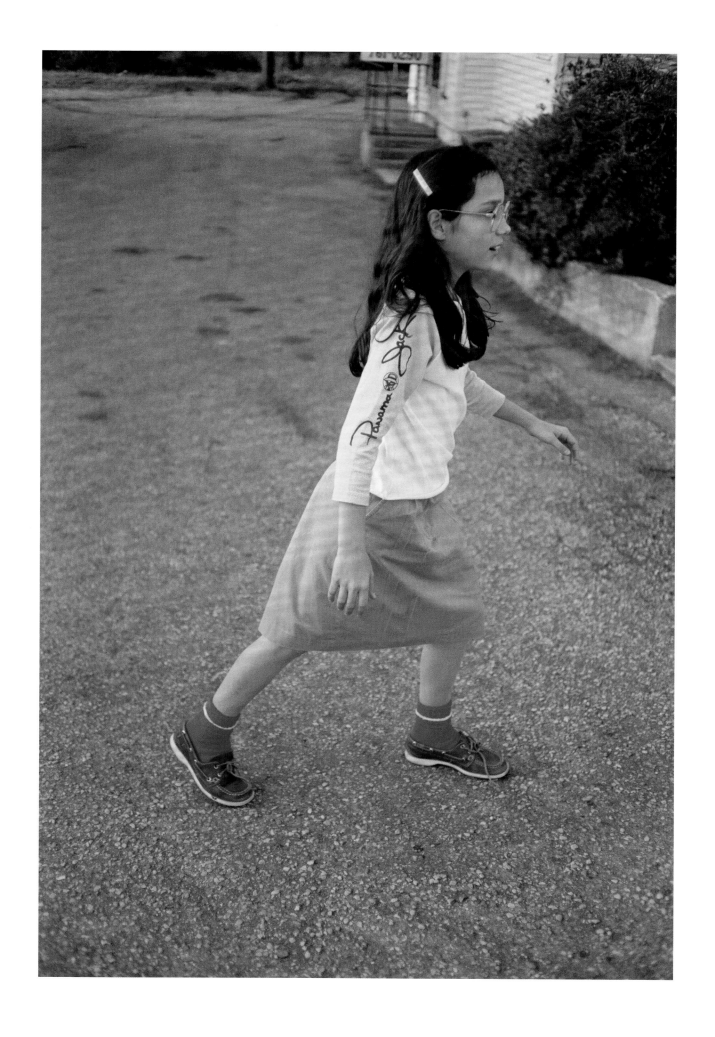

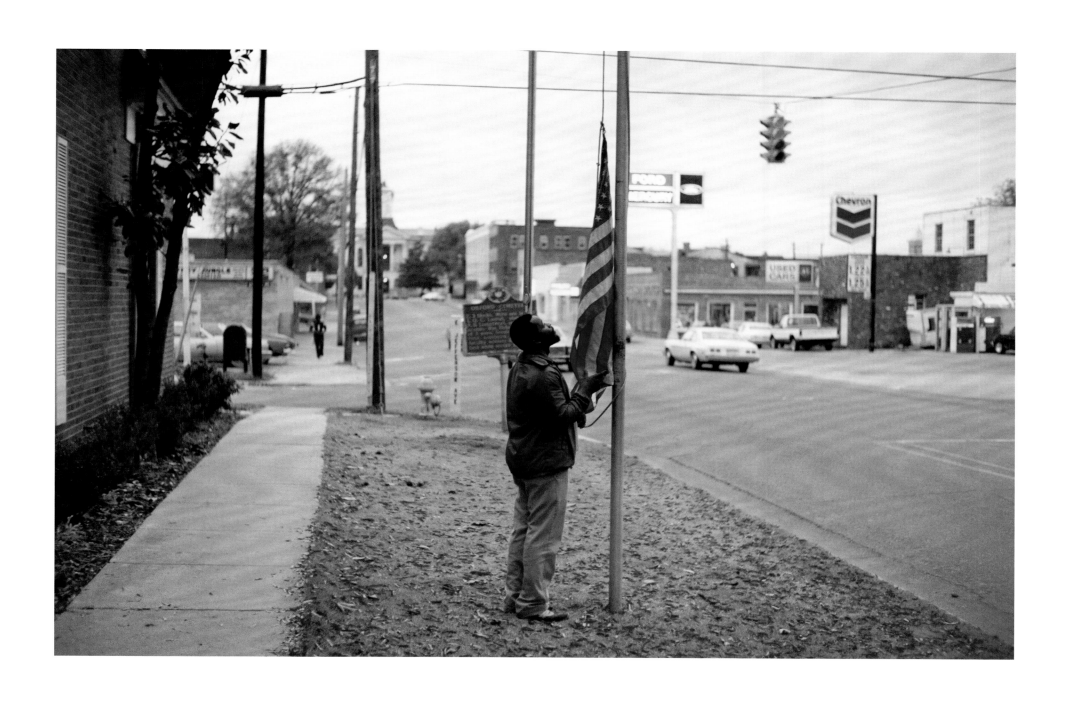

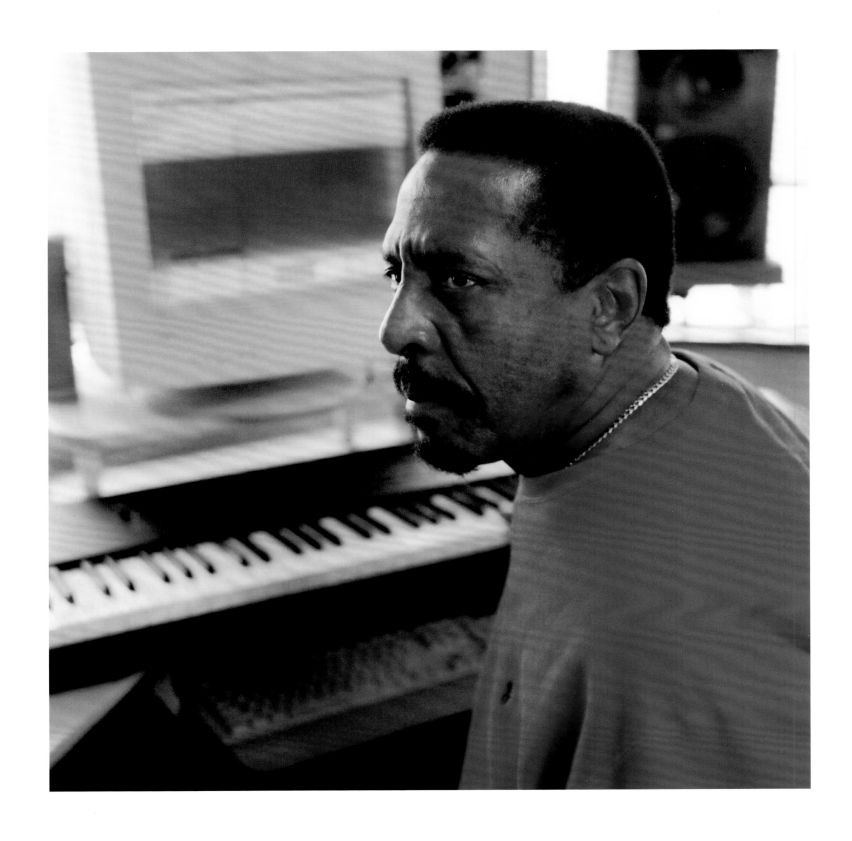

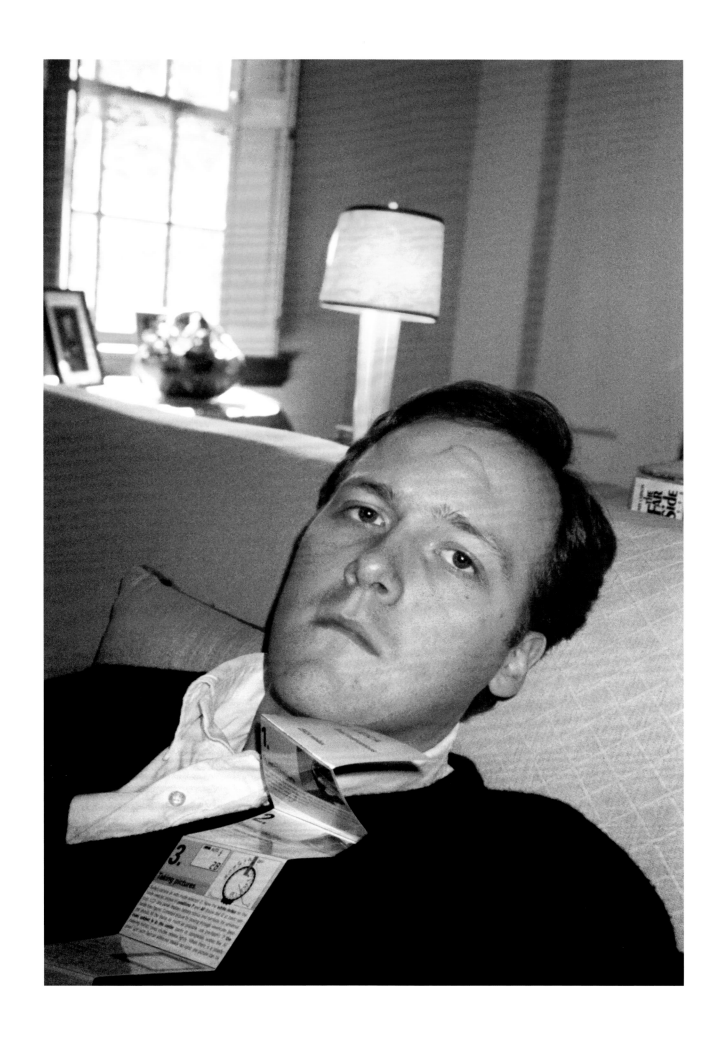

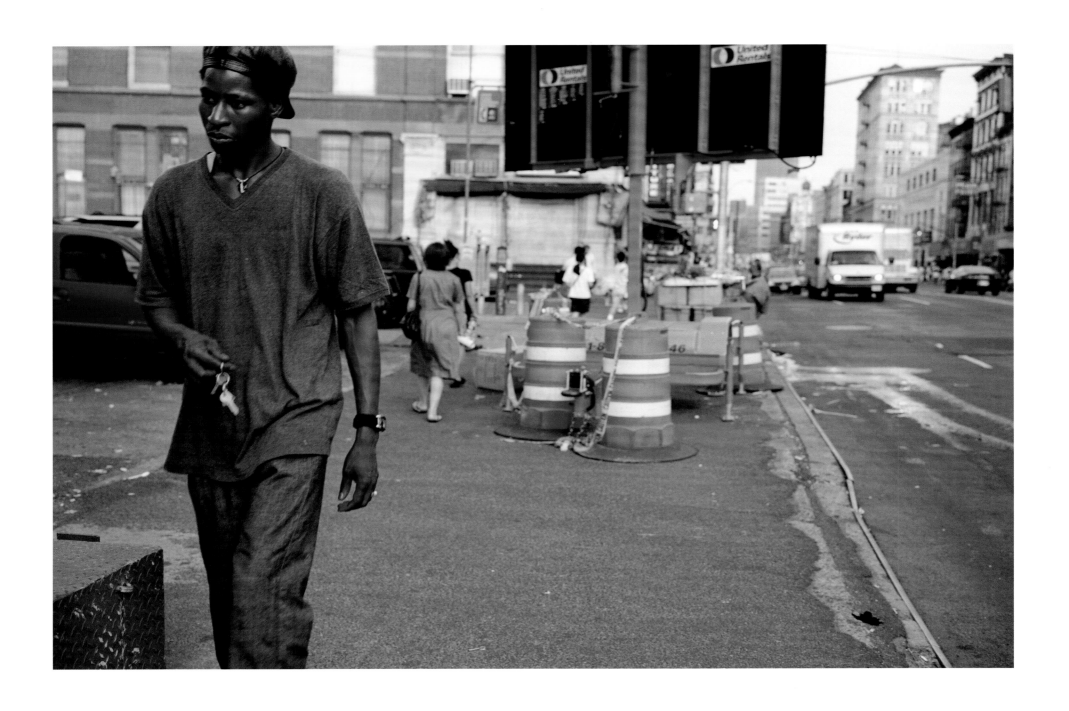

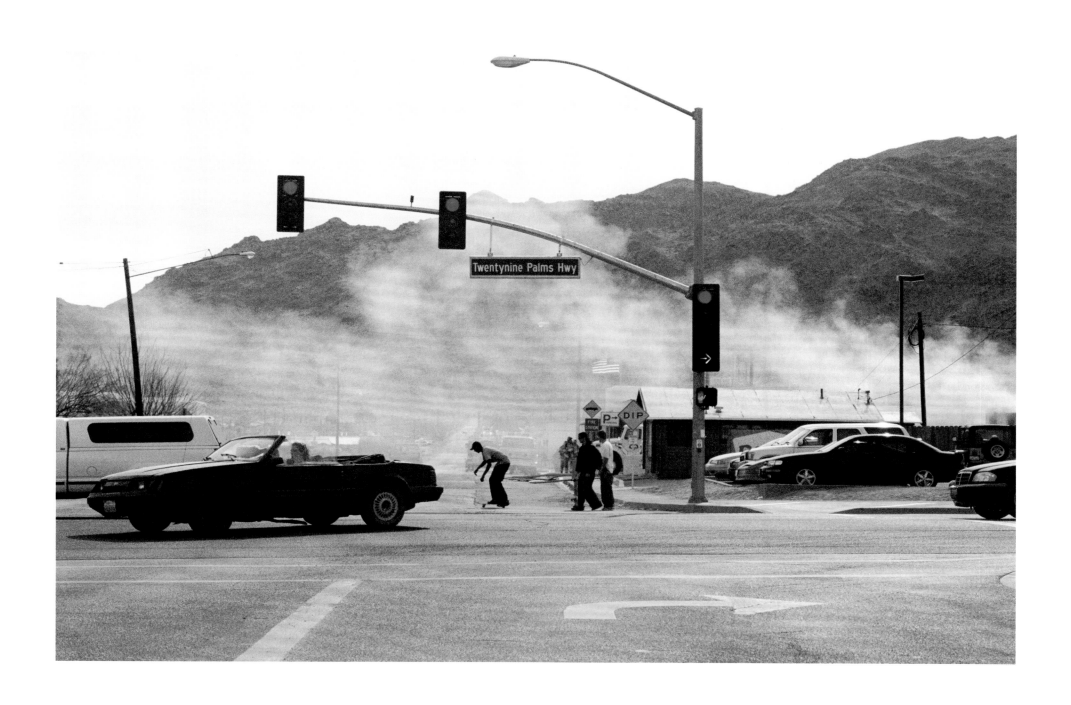

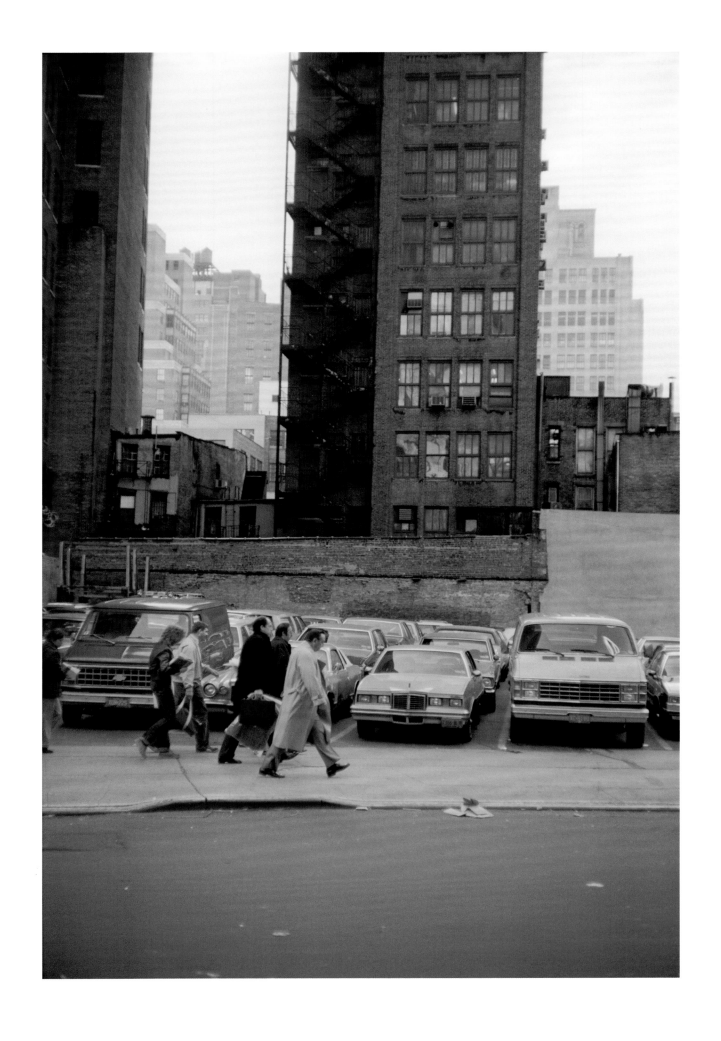

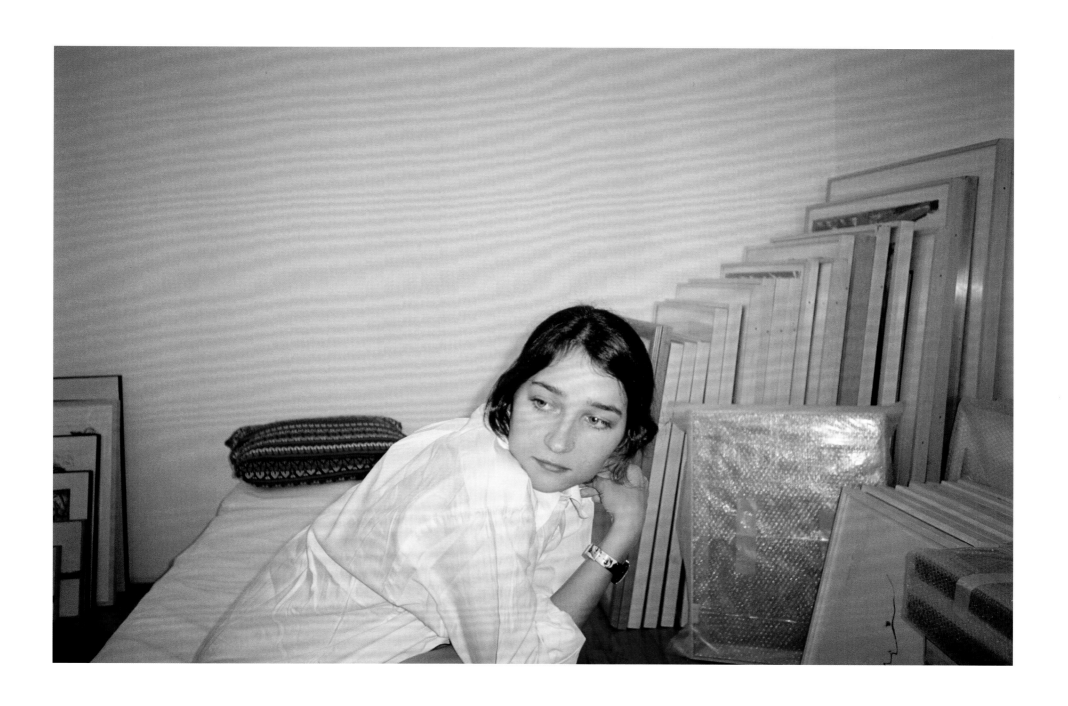

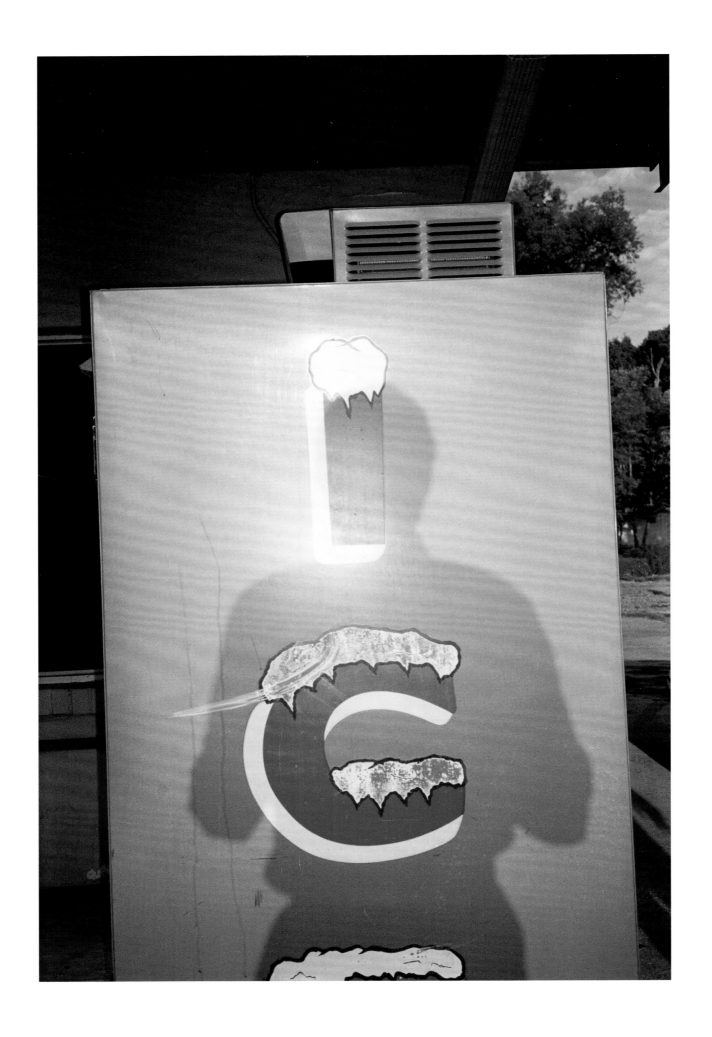

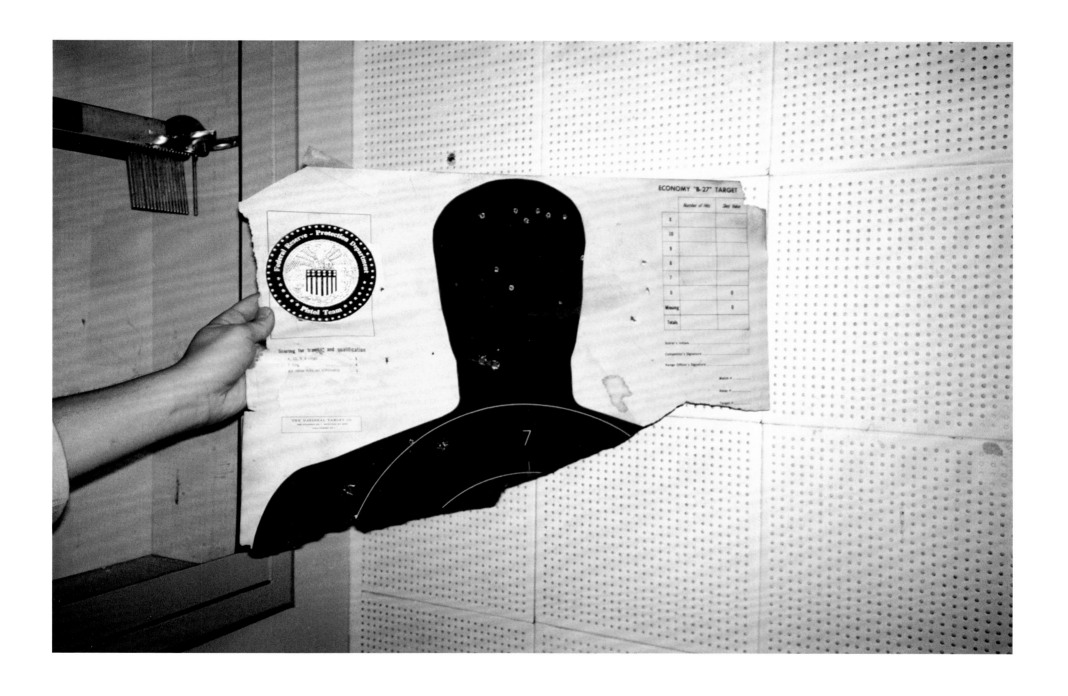

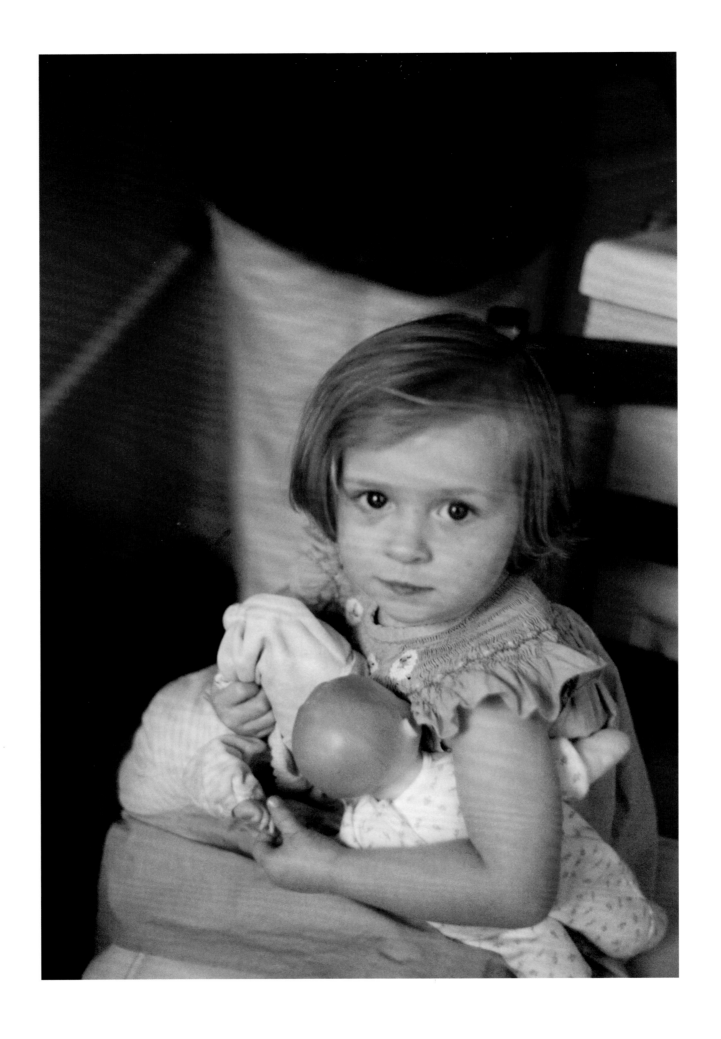

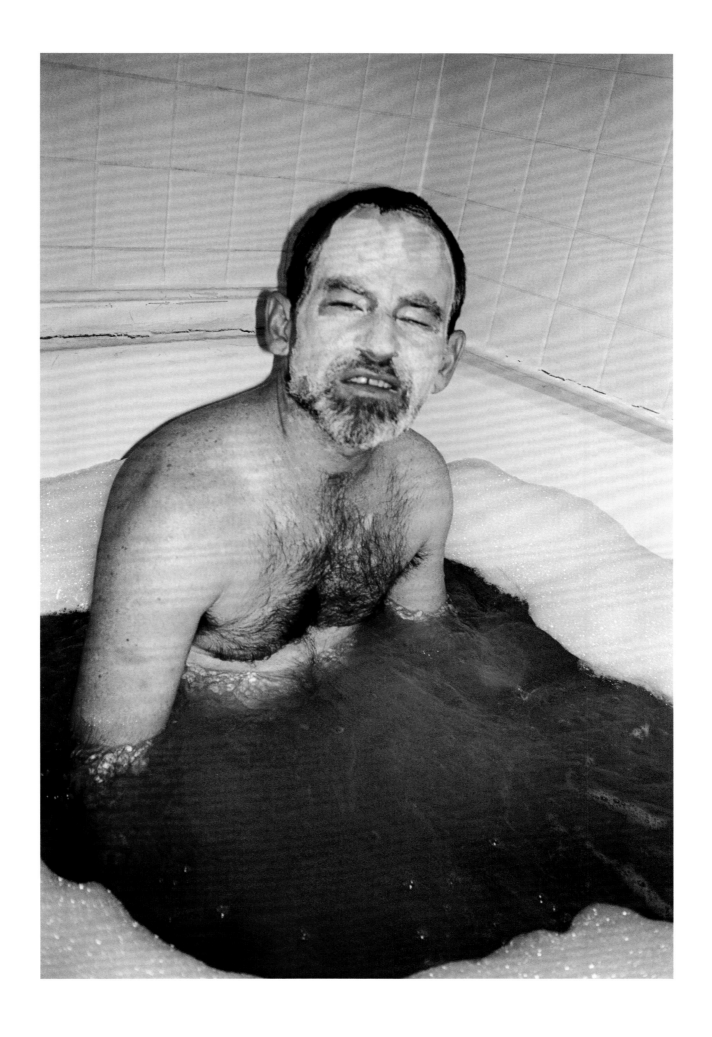

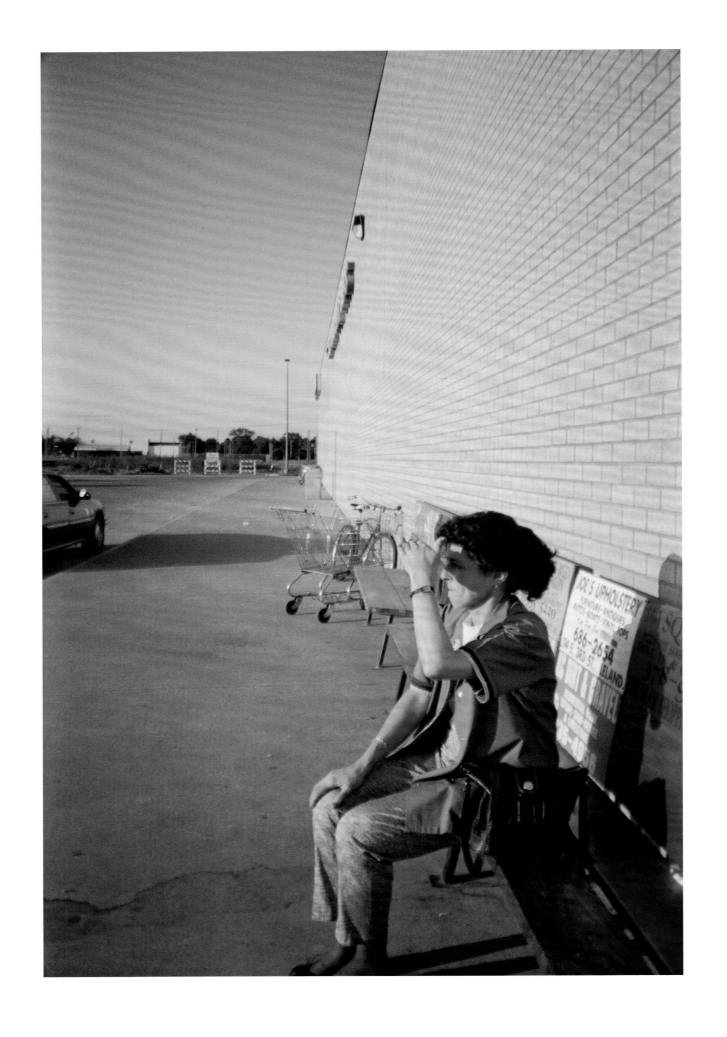

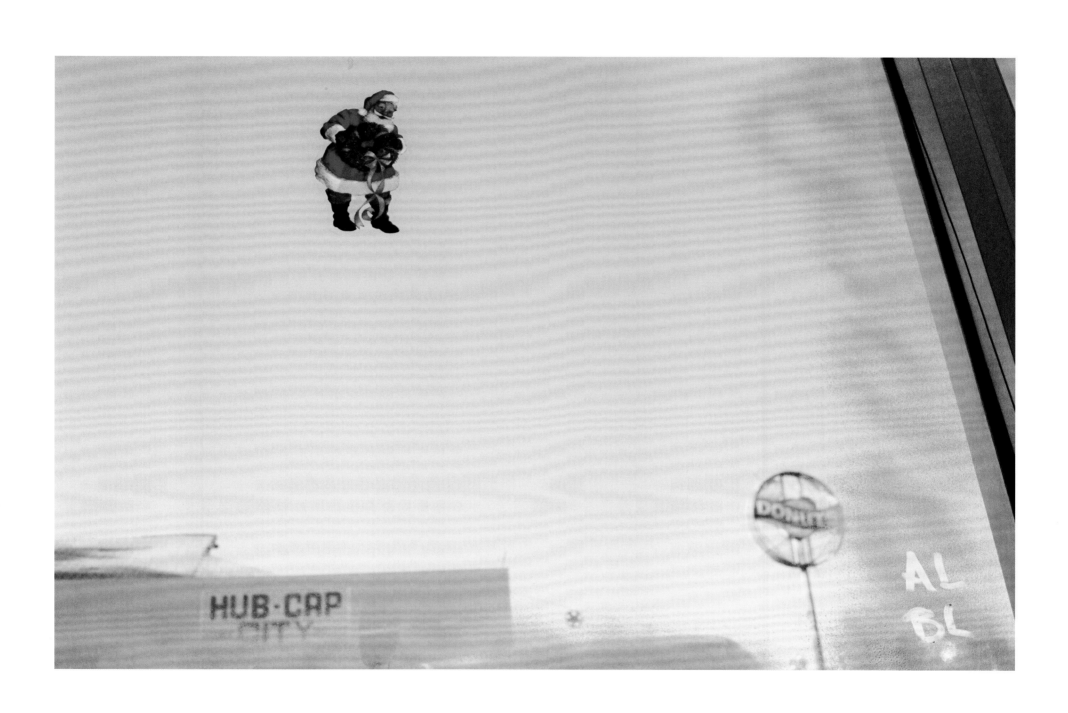

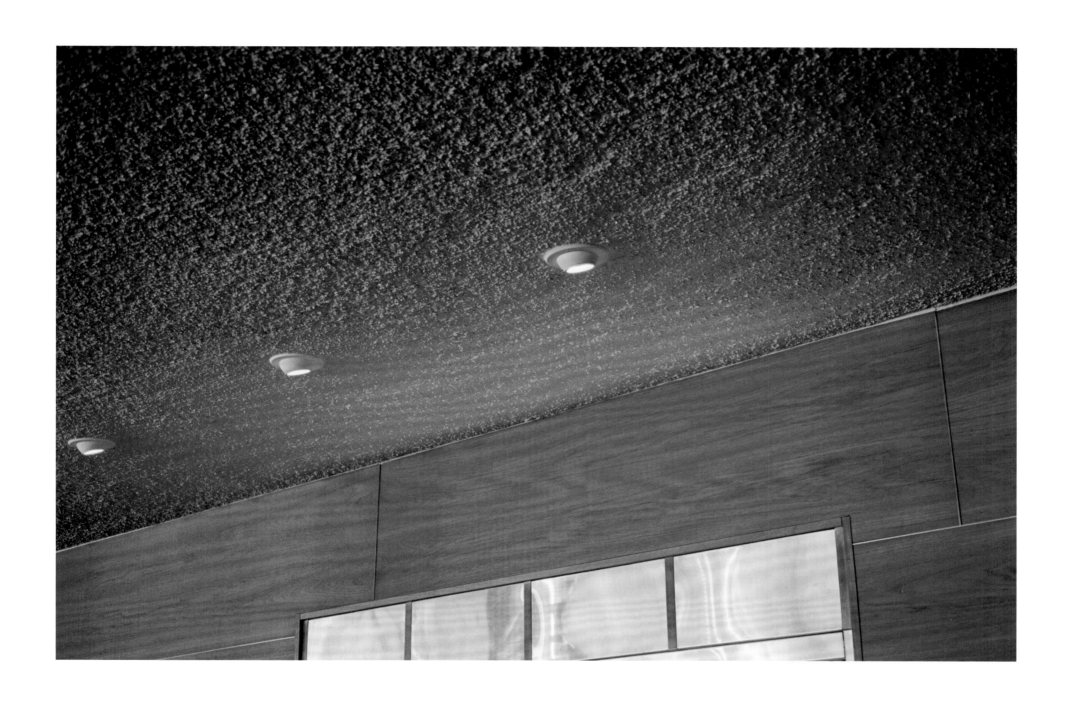

Plates

This index is offered as a guide to identify people in the pictures and to spell out locations and dates, when known. All the photographs, strictly speaking, are untitled.

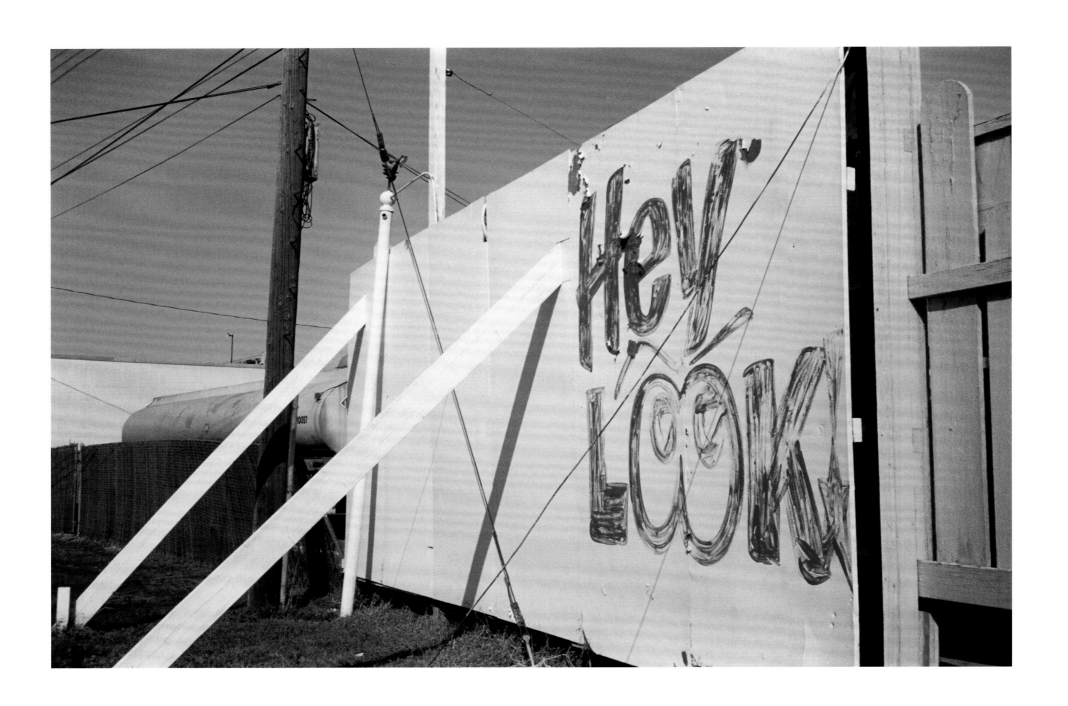

Afterword *Michael Almereyda*

THE PHOTOGRAPHS GATHERED HERE WERE SELECTED from four decades of work, roughly 35,000 digital scans, accessed on a laptop computer anchored at the Eggleston Artistic Trust in Memphis, Tennessee. I wanted to survey unseen, unpublished images — material largely absent in *William Eggleston: Democratic Camera,* the wondrous Collected Hits retrospective still traveling as this book goes to press. That exhibition's hefty catalog, featuring 134 plates, is rich and all-encompassing enough to warrant the question: where are the B-sides, the bootlegs, the unreleased tracks?

I made five trips to Memphis, during which it was possible to be methodical, patient, and discriminating — but just barely, as any sense of curatorial dispassion was overwhelmed by steady surges of sheer pleasure. ("If it ain't a pleasure," wrote William Carlos Williams, "it ain't a poem.") Reviewing Eggleston's work in this way, the flow of images, the torrential nature of his picture-making process, registers as a sprawling but precise visual diary, a record of things firmly seen or glimpsed and grabbed at, an inventory of experience.

Such an immersion, it almost goes without saying, underscores the idea that *perception* is a sustained theme, a central subject, for Eggleston. His photographs are always *about looking.* They distill a sense of heightened attention — alertness, anticipation, awe — from fragments of ordinary, unmanipulated reality. Beyond that, as has been noted fairly often, the "ordinary" in Eggleston can become charged with an air of mystery and menace, a Halloween atmosphere leaking into every season he records, a quality of vulnerability and play converging with a sense of unease, dread, the possibility of mayhem. At any rate, the photographs that excited me most tend to reconfirm this impression.

This book is tidier, more self-contained, than I first expected — a bouquet brought back from an archival jungle. I favored images carrying narrative implications, traces of a story that might exist, almost mockingly, just outside the picture frame. The majority are photographs of people — an inversion of Eggleston's true ratio of populated to depopulated images — and many of the subjects are the photographer's blood relations and close friends. That's Eggleston's wife, Rosa, on the cover and in four other photographs, a young woman evolving into a mother of three children: William III, Andra, and Winston — kids conspicuous in other books, though Mrs. Eggleston has never shown up earlier.

An air of offhand intimacy figures as something of a binding agent, in these and other images. The emotional temperature is at once tender and aloof, extending to pictures of strangers in parking lots and suburban yards, and this can seem aligned with Eggleston's enduring fascination with frayed commercial spaces, cars, signs, cracked pavement, light bulbs, bricks, clouds; with rural porches, phone poles, pegboard, broken fences, spilled trash, ditches, puddles, architectural gaps and divides — with the spaces between spaces, the mundane, the makeshift, all the fragmentary raw proofs of civilization as a perishable human construction that, nevertheless, provides subject matter for vivid and vibrant photographs.

What else? The pictures were all taken in the continental US. (Three exceptions: Rosa Eggleston faces a hotel mirror in Paris; Lucia Burch relaxes on a hotel bed in Berlin, and Cotty Chubb stands near the shore of the Indian Ocean, about 50km north of Mombasa, in a photo that's part of an unpublished series titled "The Streets Are Clean on Jupiter.") The black and tan dog (*plate 23*) can be seen, improperly flipped, in *Horses and Dogs: Photographs by William Eggleston* (Smithsonian Institution Press, 1994); the image has been recovered and set right. Otherwise, with the exception of the Chubb portrait, none of the photographs on view here have appeared in a previous book.

When I reviewed a rough layout with Bill, he was pleased to see so many pictures he had clean forgotten about. He offered his approval alongside the bemused comment that the book comes close to being a family album. Indeed, when the inevitable Eggleston biography gets written, this volume can serve as a portrait gallery, a fairly full review of the artists principal friends and companions. While we await this biography, I'll venture a few elementary ID's, fortified by Eggleston's considered remarks.

Marcia Hare (*plates 45 and 46*). "She used to dance onstage with a hippie band called Insect Trust. Their music, you could say, was too new for me. You could say I never made the mistake of *listening* to their music. I was studying Bach at the time. I never made a mistake when I listened to Bach."

Julian Hohenberg (*plate 40*). "A cotton merchant. His fortune soared in the billions. He lost it all at once. His competitors ganged up and brought him down." Hohenberg financed the first dye-transfer portfolio of Eggleston images, *14 Pictures,* in 1974. "I don't think he'll ever know how important that was to me."

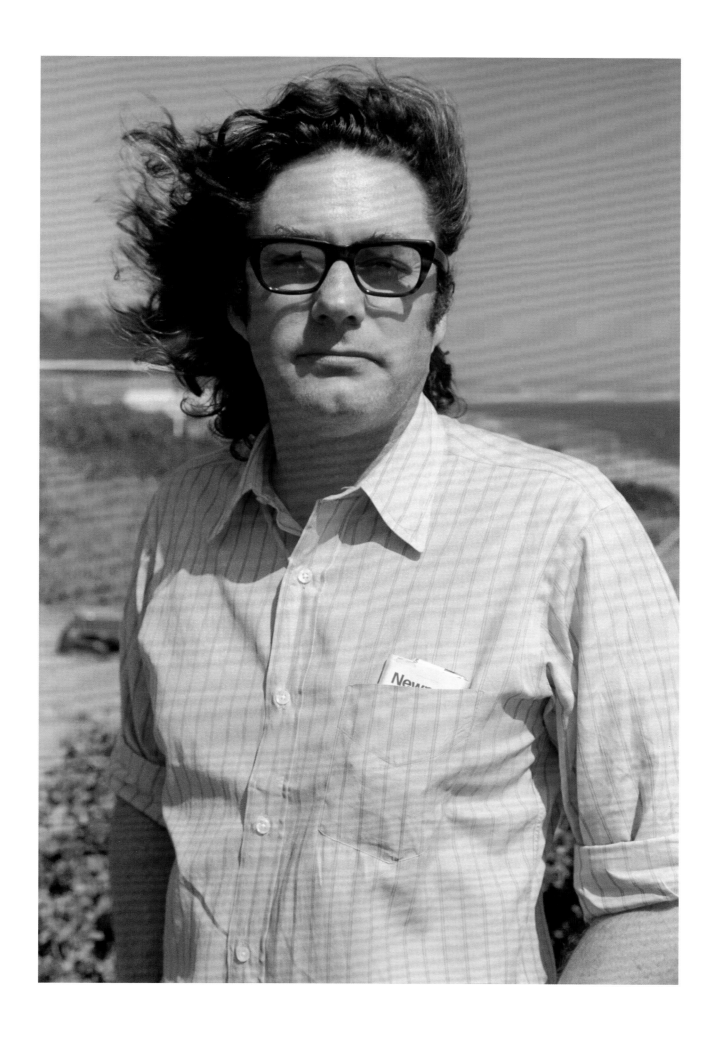

Vernon Richards (*plate 28*). "A close friend from childhood, in Sumner, Mississippi." He appears extensively in Eggleston's epic video, *Stranded in Canton*, alongside Marcia Hare and Randall Lyon (*plate 59*). Randall, a Northerner of the hippie persuasion, was a performance artist of sorts and, alternating with Vernon, assisted Eggleston in the taking of flash-lit nightclub portraits.

T. C. Boring (*plate 16*)."He was a dentist. We immediately became best friends. I can't even say why. I'll think about it, and if I come up with anything, you'll be the first to know." T. C., alone in a graffiti-scrawled room, is the solitary nude in *Eggleston's Guide* (Museum of Modern Art, New York, 1976). The blood-red ceiling, one of Eggleston's most iconic images, was located under T. C.'s roof in Greenwood, Mississippi, though this home, Bill takes pains to insist, is not the site on view in plate 16.

William Christenberry (*plate 58*) has been Eggleston's friend since 1966. Christenberry's modest and magnificent color photographs, made with a Brownie camera, served as studies for his paintings, and encouraged and confirmed Eggleston's equally transparent aesthetic.

Then there's Tom Young (*plate 47*), Eggleston's instructor at the University of Mississippi, who delivered crucial, oracular advice, commanding Eggleston to photograph things around him, even or especially things he hated. Eggleston extracted a credo from this, transforming hatred to love. His much-quoted remark —"I've been photographing democratically"— offers a measure of this reversal, his all-encompassing embrace and its Whitmanesque reach, whereby nearly every subject caught by his camera becomes part of an overflowing family album.

The book's title is meant as an open nod to the immediacy of pictures plucked from near-oblivion, a salute to their freshness. But all photographs are fixed, in the moment of their creation, in a vanishing here and now, and the title is also intended as a concession: any effort to organize Eggleston's work, to wrangle and tame it between covers, is by its nature provisional and incomplete.

I've crowded in a selection of concise texts, here at the back of the book, deferring to the idea that pictures may illuminate themselves, kindle their own meanings, but commentary can provide further straw for the fire. Essays by Greil Marcus and Amy Taubin, and an interview conducted by Kristine McKenna, have been retrieved from relatively

out-of-the-way sources. I consider this material essential to my own understanding of the photographer. Lloyd Fonvielle's piece, commissioned for this occasion, is both a decanted memory and a reminder that Eggleston has always been playing for high stakes. Finally, my fitful thoughts on the subject, originally intended for a DVD booklet accompanying my movie, *William Eggleston in the Real World,* have been slightly updated since they appeared in *The Believer* in 2006. It's the best I can offer (for now).

POSTSCRIPT

On the occasion of this book's fourth printing, ten years after the first edition, eight additional Eggleston images have been inserted (*plates 48–54 and 61*), plus a picture of the photographer taken in Memphis last November (*plate 97*). The book he's holding up shows a 1974 photo by his friend Lee Friedlander.

As of March, 2020, Eggleston moved out of his suite in the Parkview and is living with his son Winston, daughter-in-law Elizabeth, granddaughter May, and three cats, a short drive from the Eggleston Artistic Trust, where his work remains inventoried and archived.

When I last called, on his 81st birthday, Bill was smoking in the backyard, allowing that he recently accompanied Winston on a drive while brandishing an old Leica, taking pictures out the window. He was relishing the thought of an exhibition of newly digitized, enlarged prints—more unpublished work from the 1970s—scheduled to be mounted in Hong Kong in the fall.

Thanks to Winston Eggleston, Jack Woody and Kevin Messina for overseeing the book's adjusted contents at a time when the world's coordinates are notably off-kilter.

— *M.A., August, 2020*

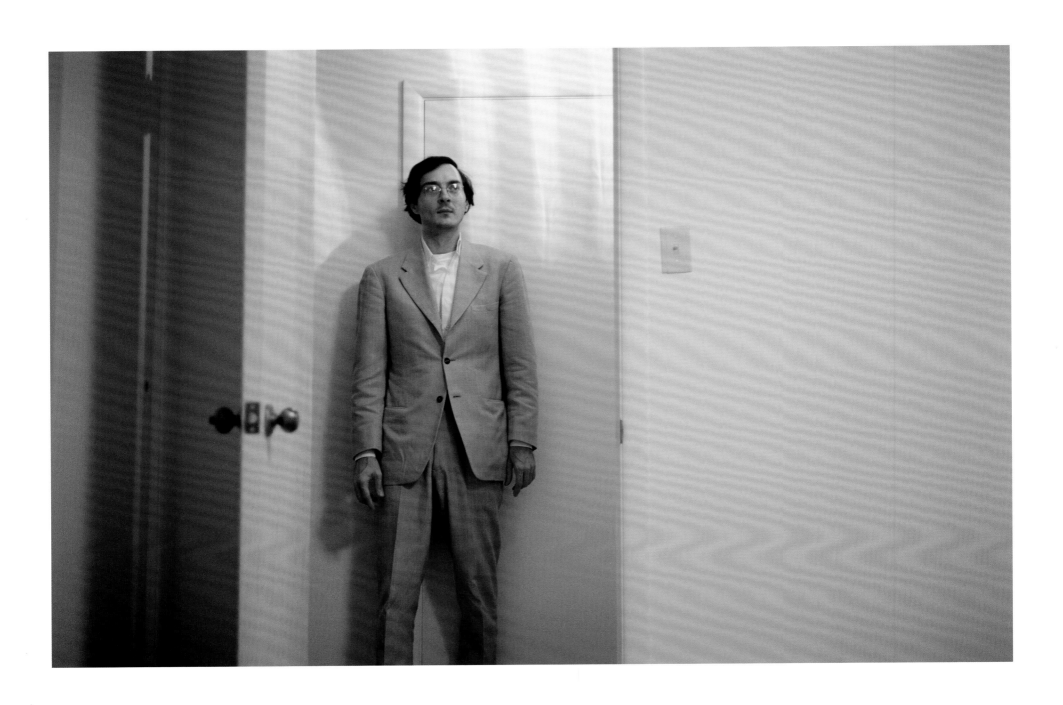

Eggleston 1971 *Lloyd Fonvielle*

WE CALLED BILL EGGLESTON FROM A PAY PHONE at a gas station on our way into Memphis. A friend in New York had given us his number and told us that Bill, a photographer he knew, would be happy to put us up for a day or two — but he hadn't bothered to mention this to Bill. Bill took us in anyway.

This was in the fall of 1971. I was 21 years old, driving from San Francisco to New England with a friend from prep school days, Lang Clay. I was a recent dropout from Stanford, Lang a recent dropout from Harvard, and we were off to discover America.

Lang and I were photography nuts, obsessed with Walker Evans in particular, but we had no idea what kind of work Eggleston did — he might have been a wedding photographer for all we knew.

When we arrived at his house — no artist's garret but a gracious Southern home — we met a rather dashing fellow in a crisply pressed Oxford shirt and khakis. He looked like a young doctor on his day off. His face, mostly expressionless but striking, reminded me of Buster Keaton's. He rarely smiled or laughed, then as later, except when telling or listening to a good story.

He offered us some iced tea and showed us into his living room, inviting us to have a seat on the couch in front of a TV set. He turned on the set with the sound off, and we all sat watching the silent images for a long time — a very long time. Nobody talked.

I found the exercise fascinating, since almost all images are fascinating if you study them intently enough, looking for what they show rather than what the image-maker tells you they show. After a while, Bill said, "Would you like to see some photographs?" We said we would.

I've always thought the TV session was some kind of test by Bill, to see if we were capable of looking at images with real concentration, but I don't know — maybe it was just something he liked to do.

Then Bill showed us his work — hundreds of color slides projected onto a wall in the living room, which we studied in almost total silence. Once, when a shot of some

scruffy grass on an embankment next to a highway overpass came up, I said, "That really just sums up the look of an American highway." Bill said, deadpan, "I took it in Scotland."

I grew up in the South, so I knew the world that most of Bill's images recorded, but I knew it without knowing it. Bill photographed the spaces between the things one would normally find interesting to note. His eye organized space in a different way than Evans's eye organized space—often reflecting the way we see things from a moving car. When Bill photographed a building, he almost always showed you where the cars were meant to park outside it.

I knew I was seeing something extraordinary—a record of the American landscape, and the American mind-set, in the second half of the twentieth century . . . something new and profound.

On a bright October afternoon during our brief visit, Lang and I went out with Bill and his son, Little Bill, on a photographing expedition. We ended up at a lawn sale—its surreally ordinary dislocations, odd pieces of furniture sitting out in the front yard, attracted Bill's attention, as did a kid with his bike on a sidewalk. Bill never said anything to us about his work, but on this visit I began trying to process it intellectually—to come to grips with its complexity, its radical insights into ordinary things.

I can't say, nearly forty years on, that I've gotten anywhere near the heart of it, on a conscious level—the work, and the things it records, are too mysterious to make sense on that level. I know that the work has opened up the world to me in startling ways, given me access to things I knew without knowing, saw without seeing. In a sense that's the greatest gift art can give, showing us the things that are hiding in plain sight.

A hundred years from now, five hundred years from now, when people want to know what America in my lifetime looked like, what it felt like to inhabit America then, they will have Bill's work to inform them of these things. We can say to those future generations that his testimony has been in all respects faithful and true.

Lang and I drove about three thousand miles on that trip to discover America, and we found it—in a slide carousel on top of a piano in Memphis, Tennessee.

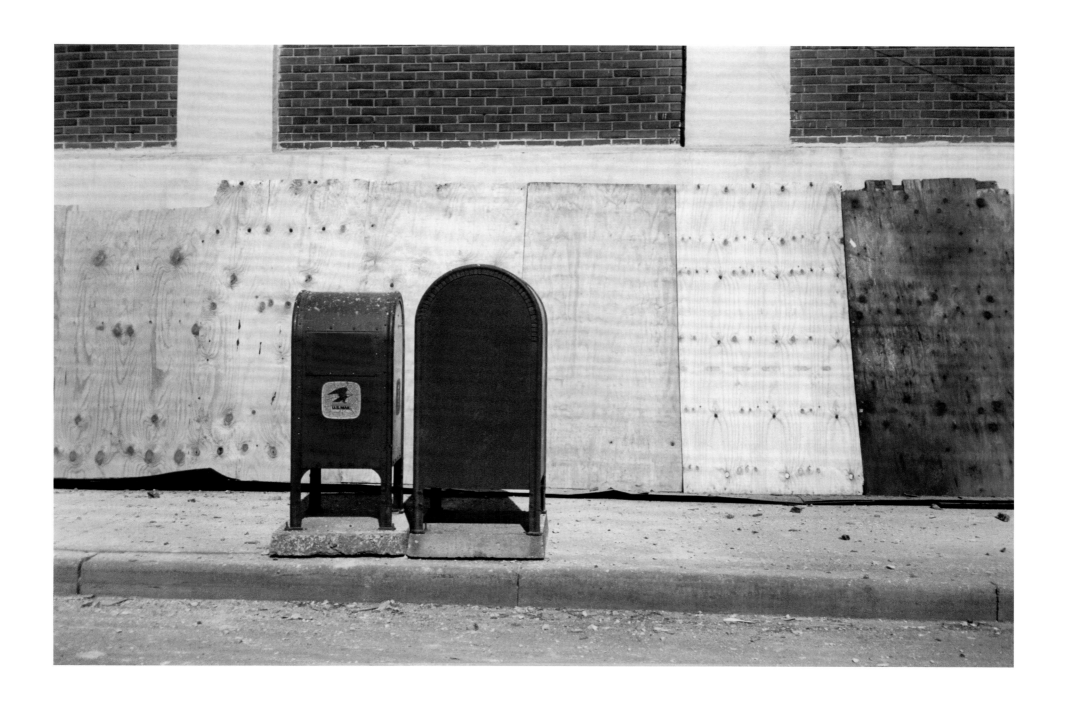

In Conversation with
William Eggleston *Kristine McKenna*

In the spring of 1994 William Eggleston visited Los Angeles to shoot a portfolio of photographs of Hollywood. For various reasons it fell to me to squire him around town during the week he spent here, and I consequently had the good fortune to have several long conversations with him. A few of those conversations took place in his room at the Chateau Marmont, with a tape recorder running. The following excerpts are drawn from those tapes.

I GUESS YOU COULD SAY MY CHILDHOOD WAS IDYLLIC. The sharecropping system was still in force, and we were the privileged class. My parents had a great respect for art, and two of the first things given to me as a child by my mother, who was a brilliant woman, were books on Rouault and De Chirico. My parents always encouraged my interest in art even though they thought a career as an artist was crazy. They figured I could never make a living at it.

When I was growing up it was thought I'd be a concert pianist because I could play anything by ear, but I never did take up the discipline. A musician has to give his entire life to his work, and I wasn't prepared to do that. I've continued to work on music throughout my life, though, and the only reason I've never done anything public with it is that I have enough on my hands trying to get people to understand my photographs.

When I was 15 I was sent to a private school that I hated, then I tried a few other schools before ending up at the University of Mississippi in Oxford. I was there for five years studying painting, and the painter I liked the most during that period was Franz Kline. I also liked De Kooning and Pollock. Abstract Expressionism was the dominant thing when I was coming of age as an artist, and I went to New York and looked at a lot of that stuff. I was painting abstractions myself at the time, and although most people don't know this, I've never stopped painting.

I never got a degree because I couldn't see any sense in taking tests. I didn't mind going to classes, but taking a test? For whom? And what would I do with a damn degree

anyway? Because I refused to take tests I had to talk the dean into letting me back into school every year, and that was hard because they didn't think I was particularly talented. At the time I was doing the groundwork for photography, and photography was barely even taught then, much less considered an art form.

When I was ten years old I was given a Brownie camera and I took some pictures of my dog, but they weren't very good. That left me completely disenchanted with the idea of taking pictures, and I continued to hate it until the late '50s, when a friend in boarding school made me buy a camera. Then I began to get it. Then I saw a copy of Cartier-Bresson's book, *The Decisive Moment,* and I really got excited about taking pictures.

I don't see many movies, but there were a few films where the color was used brilliantly, and they made a big impression on me—Alfred Hitchcock's *North by Northwest* and *Bonnie and Clyde* are the two I'm thinking of in particular. Something clicked in me when I saw those films—maybe it was just one minute out of the whole movie. During the same period that I was thinking about those films, I had a friend who had a job working nights at a photography lab where they processed snapshots and I'd go visit him because we were both night owls. I started looking at these pictures coming out—they'd come out in a long ribbon—and although most of them were accidents, some were absolutely beautiful. So I started spending all night looking at these ribbons of pictures.

I was particularly struck by a picture of a guy who worked for a grocery store, pushing a shopping cart out in the late-afternoon sun—that one really stuck in my mind. I started daydreaming about taking a particular kind of picture, because I figured if amateurs working with cheap cameras could do this, I could use good cameras and really come up with something. I'd already become proficient in black and white, I was a good technician, and I had a natural talent for organizing colors—not putting all the reds in one corner, for instance. That was probably because I'd studied painting — essentially what I was doing was applying intelligent painting theory to color photography.

People just hit the roof when my pictures where shown at the Museum of Modern Art, New York, 1976. That surprised me, too, because the work was in such a hallowed institution. Everybody screamed, "This isn't art! Why is this in a museum?" I'd intentionally constructed the pictures to make them look like ordinary snapshots any-

one could've taken, and a lot of that had to do with the subject matter—a picture of a shopping center parking lot, for instance. Because the pictures looked so simple a lot of people didn't notice that the color and form were worked out, that the content came and went where it ought to—that they were more than casual pictures.

People say I "shoot from the hip," but that's not really how I work. What happens is, when I look at something it registers on my mind so clearly that I can be loose when I shoot the picture. I always just take one picture of something, and I've never staged a photograph in my life, and never needed to because there are pictures everywhere. If I'm ever in a place I think is impossible to photograph I remember something Garry Winogrand told me. He said, "Bill, you can take a good picture of anything," and that's always stuck with me.

It's true that a lot of my pictures have empty centers, and that's something I probably got from studying Japanese prints and Chinese paintings. A lot of those things are constructed so that everything is in the borders and there really won't be a center—maybe just a little wisp or something. Western culture is hooked on the idea of the main thing being smack dab in the middle because people are so stupid. Most people look at a picture, and if they don't see something recognizable in the middle, they move on to something else.

My work has been described as documenting a vanishing South, but that was never something I was conscious of. When I was taking the pictures those critics are probably referring to, as far as I knew those things were there for good. I didn't know that five years later this incredible Coke sign would be replaced by a 7-Eleven. That possibility never dawned on me, because up until the '60s the South looked pretty much as it had during the Depression. But from the '60s on it became a different ball game, and it's unrecognizable today from what it was. You been to the South lately? It's not interesting bad like L.A.—it just looks like a bunch of idiots put the place together.

I've never understood why people describe my work as romantic, because I don't romanticize the world. If you could turn back time and look at a place as it was when I photographed it, I think the picture and the place would look pretty much the same. I've never felt the need to enhance the world in my pictures, because the world is spectacular enough as it is.

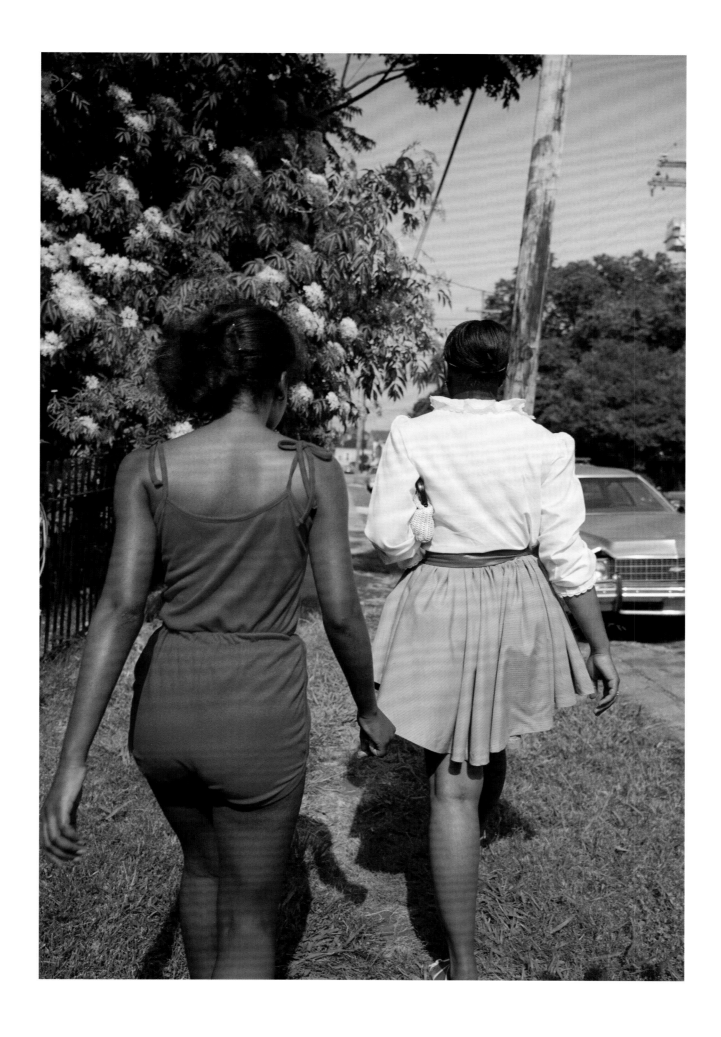

Two Women and One Man *Greil Marcus*

AS A COLORIST, HE STAYS AWAY FROM MOVEMENT. Movement distracts the eye; his rich, rich reds, yellows, greens, oranges focus it, but not on any single object. His color gives you the sense that someone has just turned on a light after you've spent minutes trying to orient yourself in a darkened room. Everything explodes with color; you don't know what to look at first, and for a moment the room has no center.

Eggleston almost always makes you feel as if you're looking at something familiar, banal, not for the first time, but as if for the first time some genie in the filling station, light fixture, or child's jacket has invited you to see its inner life: what it wants. That can't happen when a subject is already parading its own autonomy, when it moves. In his signal 1992 collection, *Ancient and Modern* (photographs from 1963 to 1990), there are very few people, and almost no movement. The one exception, a 1989 shot of London tourist busses, with two pedestrians crossing the street (that's it: everyone else on the street is standing still), looks like an illustration from a travel brochure.

Here the two women are moving forward; how fast, you can't tell. The feeling is of a Memphis morning (in fact, New Orleans) in its August sweatbox, so the women probably aren't moving quickly—but they do seem to be moving deliberately. They seem to be very consciously holding their heads straight, as if not wanting to glance side to side. The woman on the right, her purse stuck demurely under her left arm, could be on her way to church, but not likely the woman on her left, perhaps her sister. But if a white man happened to turn up behind them with a camera, how would they react? Would they turn around? Would they try to ignore him? Would they try to get away?

Imagine the picture as a movie still. Then a sense of menace, of danger, creeps out of the image. Eggleston doesn't make his presence known in his photographs; here it's unmistakable, whether it's Eggleston, photographer, or the same person, off-camera, playing the stalker, the rapist, the racist thug, the killer.

With a black-and-white photograph, all of this would be film-noir obvious, clichéd, and contrived. Here it's nothing of the sort. You're attracted first by the gorgeous red sundress of the woman on the left, then the happy whiteness of the blouse and purse of the woman on the right. Then, perhaps, you're suspicious. You wonder what sick

fantasies the photographer might be playing out as he stages, or chases, his little tableau. You wonder if you're sick to impute such ridiculous motives to a lovely scene that no doubt simply caught the photographer's eye. You focus on the dresses again, but the photograph won't hold still.

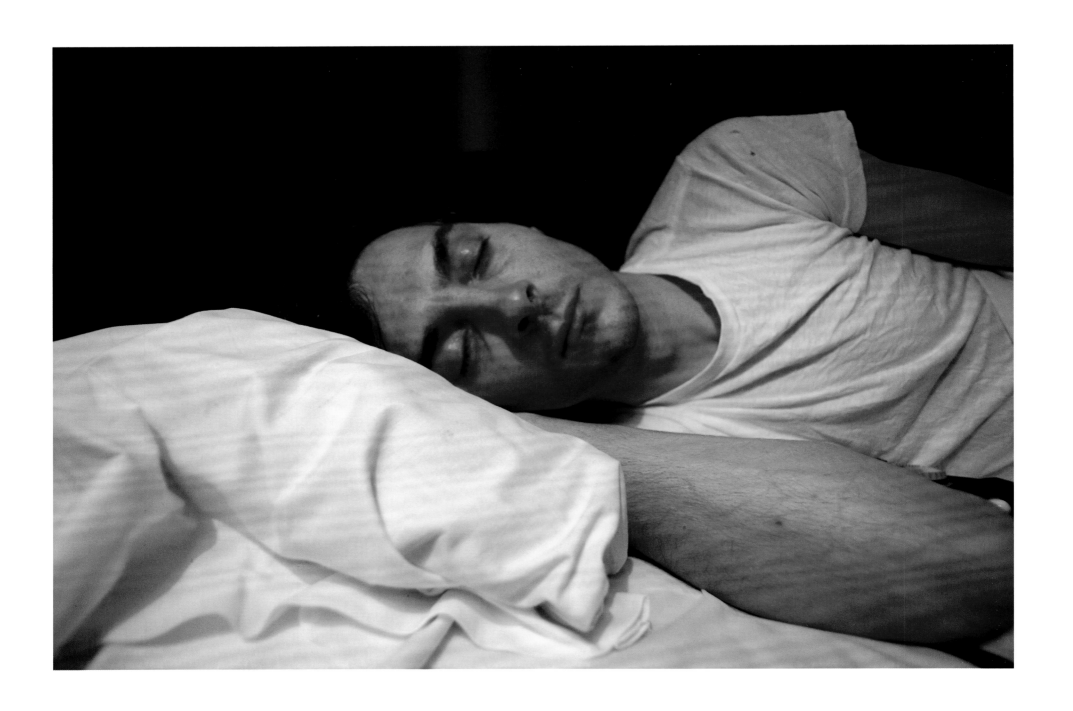

Night Vision: The Cinema of William Eggleston *Amy Taubin*

IN 1973, WILLIAM EGGLESTON BOUGHT TWO SONY PORTA-PAKS. A black-and-white camera that recorded on reel-to-reel half-inch videotape, the Porta-pak was the first video rig priced for the consumer market and, although ridiculously cumbersome by today's standards, the first that could be used outside a television studio. Introduced to the US in 1966, it became a favorite tool of artists and political activist documentarians. The great advantage of the Porta-pak, in addition to the immediate feedback that distinguished it from motion picture film cameras, was that it could be used in extremely low-light conditions. And in the right hands, it produced images of ghostly beauty.

What Eggleston did that other artists and filmmakers from Vito Acconci to Shirley Clarke didn't was to soup-up his Porta-paks, replacing the crude zoom lens that Sony supplied with the kind of prime lenses used on 16mm film cameras. Over a two-year period, 1973–74, he shot about 30 hours of videotape. In *William Eggleston in the Real World* (2005), Michael Almereyda's documentary portrait of the photographer, Almereyda remarks of this video project that "Eggleston latched on to a particular demi-monde, and the sense of psychic disarray, intimately glimpsed, is both exciting and dismal." *Stranded in Canton*, a 77-minute edit of the 1973–74 footage, codirected and coedited by Eggleston and Robert Gordon (author of *It Came from Memphis*), had its premiere at the Toronto Film Festival in September 2005, introduced by Larry Clark and followed by a Q & A with Eggleston.

Eggleston is identified with his color work, which, since his ravishing show at the Museum of Modern Art, New York, in 1976, has not only transformed the definition of art photography but also influenced such filmmakers as David Lynch and Gus Van Sant. Eggleston brought the vivid color of commercial and fashion photography to ordinary objects, interiors, landscapes, and people. The tension between saturated palette and anti-dramatic, uninflected, slightly skewed compositions partly accounts for Eggleston's stranger-in-a-strange-land vision. Because the color work had such a huge impact, it has overshadowed Eggleston's black-and-white images. But Eggleston's New York gallery, Cheim and Read, by mounting two shows of the black-and-white work in 2004 and 2005, and also screening an early cut of *Stranded in Canton*, sug-

gested that color is a less essential aspect of Eggleston's vision than one might have thought. The poignant still photographs from the 1960s assembled under the title *Pre-color* have a relationship to the Porta-pak video simply because both are black-and-white. The *Nightclub Portraits* series, however, was produced in 1973, the year of the Porta-pak project, and is definitively one of a piece with it by virtue of the same cast of characters appearing in both. In the portraits, these drunken, stoned denizens of the night seem, for the most part, unaware that they were being photographed, and the low angle of Eggleston's camera combined with their blissful lack of self-consciousness give them an unexpected gravity.

If nothing else, *Stranded in Canton* makes us aware of the chaos outside the frame of every Eggleston photograph. One might venture, on the evidence of this swerving, lurching, ghostly video diary, that, for Eggleston, time is chaos, against which still images and the rhythms of music are two forms of defense. In the video, the subjects are aware of the camera's presence without being intimidated by it or even taking it seriously. "Put that thing away, Bill," is the movie's constant refrain. But "Bill," the ethnographer of that mysterious region called the South, homes in on art and artifacts, on family gatherings where familiarity and hostility are inseparable, on two geeks biting the heads off chickens, on juke joint philosophers and drag queens, on musicians amateur and professional, black and white — all of them grooving on their own sounds. Untroubled by the niceties of focus or any kind of propriety for that matter — at one point, the camera seems irresistibly drawn to the zippers on the pants of every man in the room — Eggleston is part of the scene he chronicles in close-up, and the undercurrent of anxiety it inspires in him motors *Stranded in Canton*. "This was back in the days when everyone liked Quaaludes," he reminisces in voice-over. It's a movie that could leave you enervated or drive you as crazy as the people on the screen.

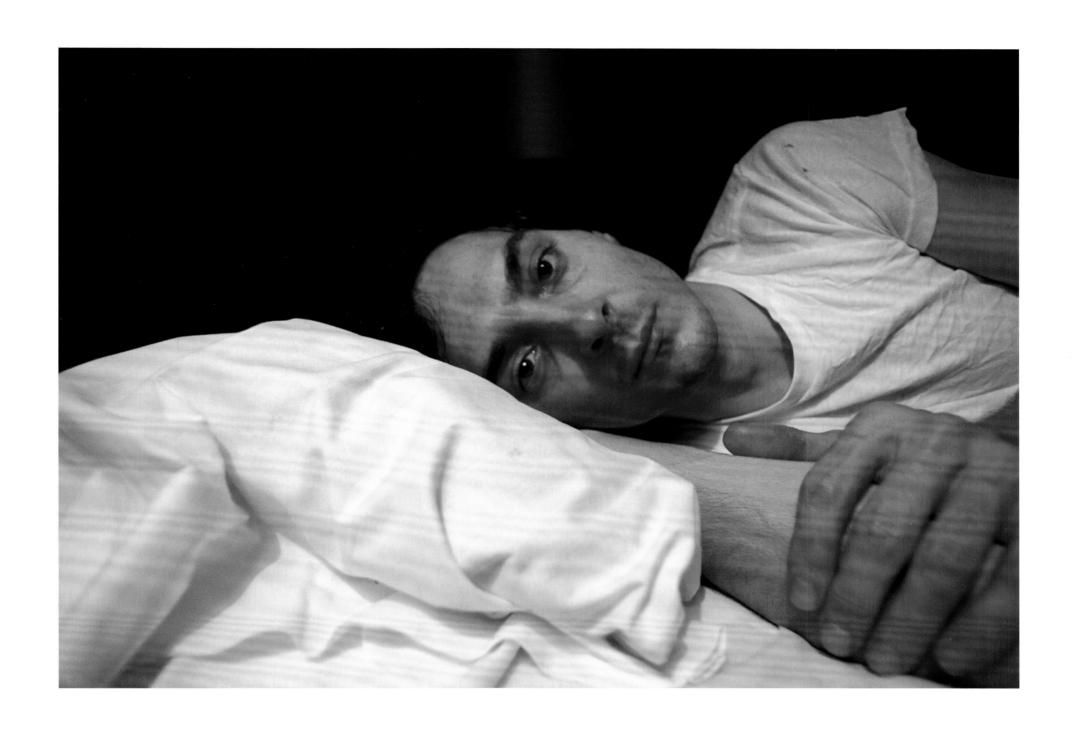

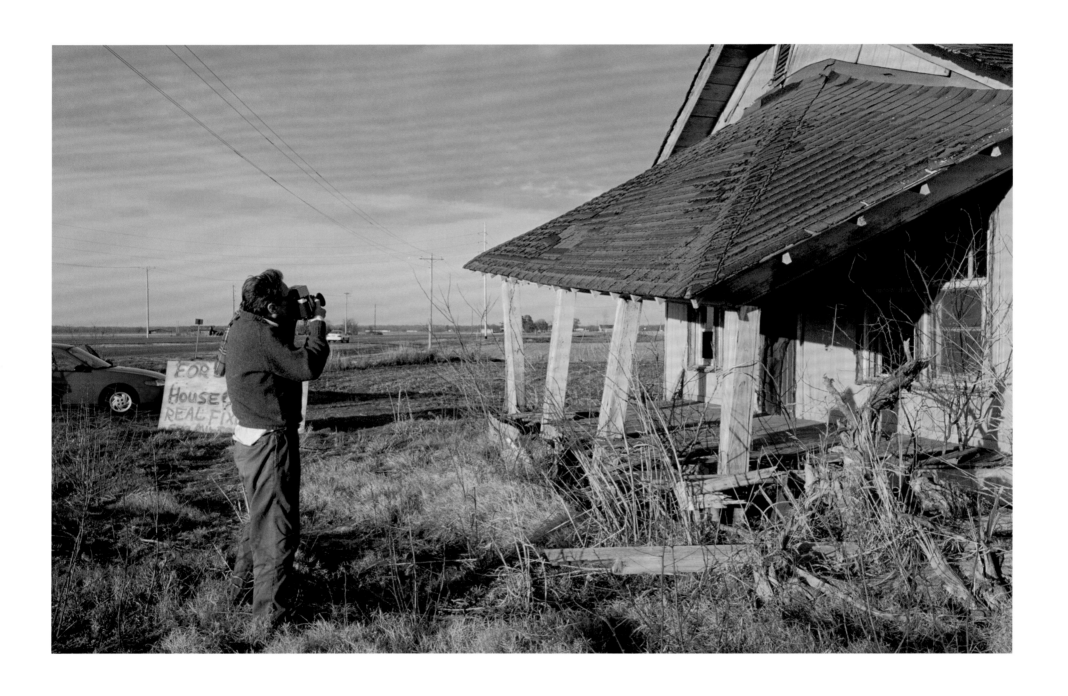

"It Never Entered My Mind"

(Answers to 11 frequently asked questions about
William Eggleston in the Real World) *Michael Almereyda*

1. I WAS IN NEW ORLEANS after taking on a job to write a film treatment covering the life of Frank O'Hara. So I was reading up on O'Hara—I knew almost nothing about him—and I became smitten. As any O'Hara aficionado knows, Frank would routinely buzz out of his office at New York's Museum of Modern Art, install himself in the display window of the local typewriter store, and dash off fearless high-speed poems. How terrific to be as quick, expressive, intuitive, and self-destructive as Frank O'Hara. He made me feel like a safe-playing plodder.

I'd also been thinking about Eggleston—when you're in the South, it's hard not to—and I saw a connection. It struck me that Eggleston was working within or near O'Hara's wavelength, ducking conventional or "classical" thinking while making photographs informed by deep intelligence, daring, and, in fact, an unexpected sense of tradition. His pictures carry something of O'Hara's quickness, candor, lightness, sharpness. There's a shared affection for the patchwork of mundane details that fill up your life. The overworked Faulkner/Eggleston analogy always seemed forced and limited to me. If you want a true literary parallel for what Eggleston does, look to O'Hara. Eggleston's pictures feel similarly tossed-off and prismatic. Hard-edged fragments, refracting a world of inner and outer experience.

When, back in New York, I mentioned this to the producer of the O'Hara movie (which remains unproduced) and relayed my wish to shoot a rough-and-ready Eggleston portrait, he found his way to an ATM and took out enough cash to get me on a plane to Memphis within the week.

Five years later, at my safe, plodding pace, I finished the movie.

2. Contax, Mamiya, and Leica.

3. Actually, when Gus Van Sant commissioned Eggleston to photograph anything he wanted in Mayfield, Kentucky, there was an obscure hope that Bill would come up with stills for a short film Gus was directing at the time. (Other movies on which Eggleston roamed the set: John Huston's *Annie,* 1982; David Byrne's *True Stories,*

1985; Kasi Lemmons's *Eve's Bayou*, 1997.) Bill took some pictures—none featuring actors—and Van Sant's movie wrapped, and it was discovered that a camera failure had blighted a number of Eggleston's film rolls. So Bill made a return trip to Kentucky after the production pulled up its stakes—which timed out nicely with my impromptu visit. After Mayfield, Bill hung out in Memphis for a couple days, then flew to LA for the slide lecture.

4. The Eggleston Artistic Trust—established in 1992, and now administered by Winston Eggleston, following an 11-year executive stint by Cotty Chubb—maintains a digital archive of nearly everything Eggleston shoots. Images the size of postage stamps can be summoned up on a computer screen, in staggering profusion, grid after grid, inventoried by approximate date. And so it's possible to review our full Mayfield trip, a visit to McDonald's, pictures snapped from the car, even a couple of shots in which I was unknowingly caught in the frame. This amounts to an incredible visual diary, but not all the pictures are amazing—how could they be?—and I chose not to show what Bill was shooting until we arrived at the abandoned house. Didn't want to clutter up the real-time flow of things, or to deflate the movie by frontloading it with pictures that were less than wonderful.

And here I can lament one gap in this fairly thorough portrait. I was never around to record the process by which Eggleston's work gets edited. Over the years, the photographer has tended to retreat and trust those closest to him—Winston, Cotty, Walter Hopps—and particular curators: John Szarkowski, Mark Holborn, Thomas Weski. Just as he trusted me to record and select episodes in his life, leaving himself the latitude to get on with living it. Thus the very name of the Eggleston Artistic Trust can be regarded as a literal component of the photographer's approach, and part of his ongoing luck.

Quick postscript: Eggleston was recently drawn into the editing process of his long-gestating *William Eggleston Paris* (Steidl and the Foundation Cartier, 2009), a book that uniquely combines his photographs and drawings. The drawings may not have alarmed anyone who saw my movie—Bill is busily sketching during one extended scene—but they do have a quality of unexpectedness. Loose or congested tangles of abstract marks made, more often than not, with acid-colored felt-tip pens, they're vibrant scribbles, at once elegant and scruffy. At any rate, Eggleston regards *Paris* with pride. "It's my first *modern* book," he told me, adding, "I'm not sure what I mean by

that, but I'm sure it's true." It hardly seems unrelated that some of his more daring photographs in the last decade have included urban graffiti, or seem to aspire to the *condition* of graffiti—aggressive, garish, unpretty, and on the brink of sheer illegibility. They make me think of late Picasso.

5. I hadn't, initially, noticed the preposterous sign: "REAL FIXER UPPER $200,000." The house was well past fixing up, at any price, but its dilapidation was, of course, perfect, and the mashed-in roof provided one standout instance whereby Eggleston broke with his claim that he takes only one picture of one thing. He took three shots of the roof. Maybe he was worried about the wind jostling the camera. That assaultive wind, abrading my camera's mike, prompted a few reviewers to condemn the movie as the work of an incompetent amateur. Truth to tell, I wanted that stark sound, chose to keep it as proof of the movie's rawness. Call it a tribute to Frank O'Hara. In other sequences, the sound editor (Elmo Weber) seamlessly subtracted this sort of noise. At any rate, it'd be hard to say which of the roof pictures is better or best.

Bill circled the place and wasn't intending to enter until I climbed in through a back window and opened the front door. The photo of light striping the floor appeared on the cover of *Blind Spot* magazine, was included in the Foundation Cartier's 2001 Eggleston retrospective in Paris, and published in the accompanying book.

6. I did my best to avoid aping Eggleston's style, manner, framing, sensibility—but you can pretty well appreciate the dilemma. Given a fair amount of time with his work, it becomes easy to assume that you, too, can take pictures like William Eggleston's. It's a measure of his vision, to apply an overused word—this way his images give off seemingly absorbable, imitatable aesthetic thrills. And so among a multitude of commercial and amateur photographers we see outpourings of pseudo Egglestons, failed *faux* Egglestons. Viva, the Warhol actress who was Bill's companion in New York through much of the '70s, coined a term for such pictures: *Fegglestons*. Given the odds, Eggleston's massive output, and the way we are all prisoners of our own unreliable reflexes, it's worth admitting that Bill himself has been known to produce the occasional Feggleston.

7. A line from Rumi comes to mind: "What a piece of bread looks like depends on whether you are hungry or not."
 Also: "Sell your cleverness and buy bewilderment."

8. There was a "pure" version of the movie, without voice-over, and I have some nostalgia for it. But on showing an unnarrated rough cut to an invited audience I became aware of a certain restiveness, if not outright hostility, and afterwards I heard things like: "I loved it, I got it, but I'm not so sure my *friends* will go for it." In the meantime, I was given a chance to view successive cuts of *Stranded in Canton,* a distillation of Eggleston's thirty-some hours of reel-to-reel video shot in the early '70s. Memphis historian Robert Gordon had layered in a recent Eggleston interview during which Bill, in an expansive mood, reminisced about people and events documented in the tapes. The names and facts and drily recounted mayhem were entertaining but had the unfortunate effect of gumming up the immediacy of the raw footage. I said it was like a DJ talking over his music. And so succeeded in siphoning a good deal of narration out of Eggleston's episodic epic while ladling it onto my own movie. (The need for explication, as you see, can easily spin out of control.)

9. Over the years, I've had cause to take issue with the assumption that a sober person is necessarily more intelligent than a nonsober person.

(All the same, I never saw Eggleston take a photograph while drinking.)

10. "It never entered my mind" is the response Eggleston offered to my persistent questions about the nature of photography, during our "climactic" exchange in Tops Bar-B-Cue. We hit a wall—"It never entered my mind!"—a fair defense against overthinking, self-consciousness, posturing. I lobbed the questions with the expectation, the certainty, that they'd be deflected. Why interfere with a process that's essentially intuitive and, often as not, inspired? A good or great photographer sees and shows more than he can say.

But — or rather, therefore — in another mode Eggleston confirms what he denies. An image of Leigh Haizlip (*plate 1*; one of the very few photos Bill took of her) provides powerful evidence not only that this particular woman existed but that the photographer had feelings for her. The medium is innately elegiac—each picture records a moment, if not a world, that no longer exists—and the formal sweetness of Eggleston's work, the seeming casualness, the throwaway grace, is fused with this implicit awareness. As with Frank O'Hara's habit of unrevised improvisation, to take "only one picture of one thing" raises the stakes in an existential game.

You can chase this thought, or you can choose to say, "It Never Entered My Mind"—which happens to be the name and recurring refrain of a Rodgers and Hart song Bill played on the piano while courting his wife. I've heard him and Rosa describe it as "our song." The lyrics give voice to the desolation of a man "uneasy in my easy chair," following the departure of his lover, despite her explicit warnings and predictions. His future was staring him in the face, but, or therefore: "It never entered my mind."

11. Is there an element of "exploitation" to the movie? Did it ever occur to me that I was being, merely, a voyeur? Safe to say that anyone making a documentary is walking this particular ledge. As a temporary foothold, I'll invoke a patch of dialogue from a recent conversation between Eggleston and Lee Friedlander — what Tod Papageorge called the "Fried Egg Event," organized by the Yale Photography Department and moderated by Gregory Crewdson, December 5, 2005.

CREWDSON: "Do you think photographs are voyeuristic?"
EGGLESTON: "Can you say more about what you mean by that?"
CREWDSON: "Sure. Just by the nature of the process of taking a picture, some way or other you are separated from the world, by your camera."
FRIEDLANDER: "I think it's the opposite. I think the camera, rather than separates, brings me in. It's the vehicle, the fulcrum, for bringing you into the world."

Another question that came up was: "Do you think photography has a connection to truth?"

"I don't," William Eggleston slowly answered, "like to think of myself as a liar."

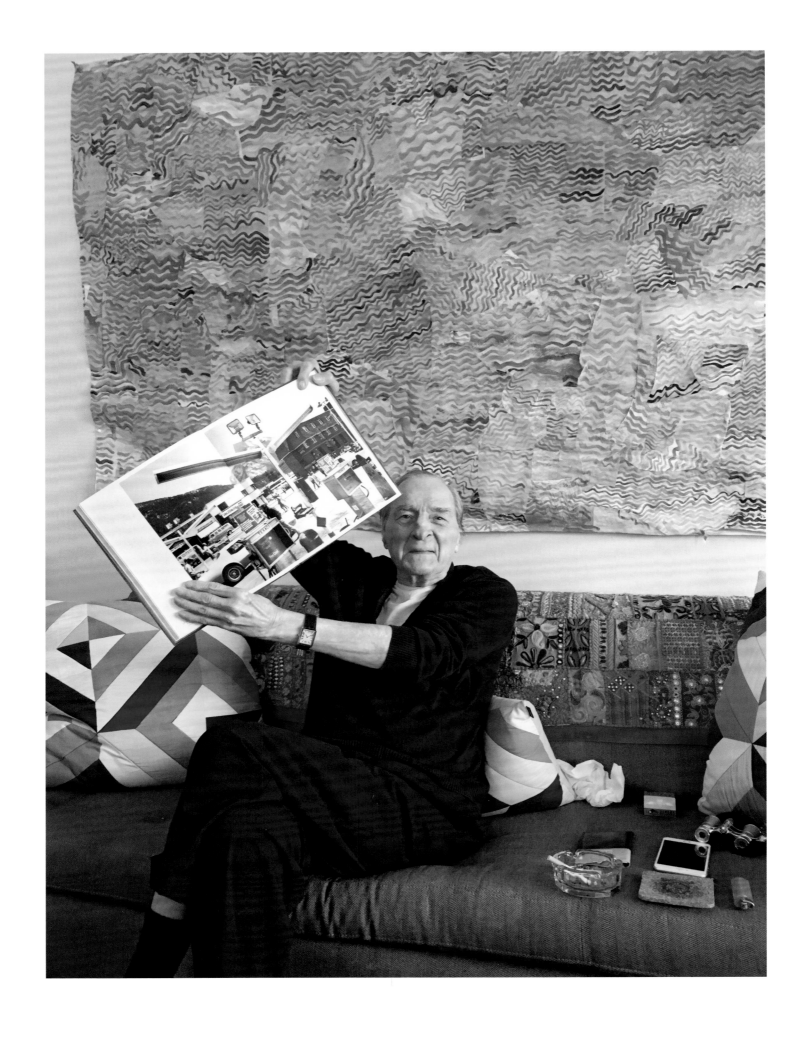

IN MEMORY OF JOHN SZARKOWSKI AND WALTER HOPPS

Acknowledgments

PRIMARY THANKS must be triangulated between three principals. Jack Woody of Twin Palms Publishers embraced and expanded my initial idea, and provided a steady supply of plane tickets and encouragement. William Eggleston graciously, trustingly granted permission to rummage in the archives. Cotty Chubb sparked to the concept and held me to a clear course, steering through various vicissitudes along the way.

The project would have proved impossible without the ground support of Winston Eggleston, who patiently shared his office and his remarkable memory for his father's images. And I owe an ongoing debt of gratitude to James Patterson, unstinting patron of the arts, for his extraordinary hospitality and good will.

Thanks, too, to Greil Marcus, Kristine McKenna, and Amy Taubin for permission to reprint their work.

Susan Kismaric, Rose Swan Meacham, Lloyd Fonvielle, Paul Graham, and Harmony Korine supplied invaluable advice and support, at crucial early steps and up to the last minute.

— *Michael Almereyda*

TWIN PALMS PUBLISHERS
Santa Fe, New Mexico
www.twinpalms.com

ISBN 978-1-931885-93-5